American Graphic Design Annual

No. 3

Visual Reference Publications / New York

Copyright © 2003 by Kaye Publishing Corp.

Visual Reference Publications, Inc.
302 Fifth Avenue
New York, NY 10001

Distributors to the trade in the United States and Canada
Watson-Guptill
770 Broadway
New York, NY 10003

Distributors outside the United States and Canada
HarperCollins International
10 East 53rd Street
New York, NY 10022

Library of Congress Cataloging in Publication Data:
American Graphic Design Awards No. 3
Printed in Hong Kong
ISBN 1-58471-028-4

c o n t e n t s

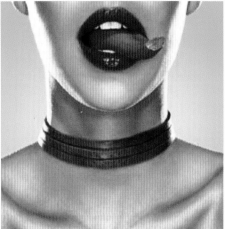

WELCOME TO THE DESIGN ANNUAL

Welcome to the American Graphic Design Awards Annual No. 3, showcasing a select handful of the nearly 11,000 entries to the American Graphic Design Awards program sponsored by Graphic Design:usa. Like our magazine, which next month celebrates its 40th anniversary, the competition is meant to be open, accessible, inclusive and, most of all, representative of the many ways in which graphic design shapes commerce and culture.

Ironically, I find myself writing this piece at deadline while on an airplane streaking over New York City, circumstances which cannot help but evoke memories of September 11 and the schizophrenic year that has followed — a period packed with a lifetime of emotions and events, triumphs and tragedies, great goodness and surpassing courage, and of despicable breaches of trust by the greediest among us. For graphic art and design, acutely vulnerable to the market and mood swings of the broader society, it has been an especially trying period.

That is why it is all the more remarkable that the American Graphic Design Awards program grew substantially this time around by every quantitative and qualitative measure. There are several possible explanations, but I choose to embrace one. That is, in the face of frontal attacks on our fundamental tenets by violent terrorists from without and white collar thieves from within, designers respond as they best know how — with a defiant and exuberant display of the power of the creative mind.

Gordon Kaye Editor/Publisher

ON BEHALF OF

Laura Roth Director, American Graphic Design Awards

Jan Schorr Associate Director, American Graphic Design Awards

Ilana Greenberg Art Director

Rachel Goldberg Production Manager

Bradley H. Kerr Assistant Editor

JUDGES

A special thanks to our extraordinary panel
of talented creative professionals from
all over the country who served as judges
for the 2002 American Graphic Design Awards.

TSIA CARSON

TSIA CARSON

Flat, New York NY

Tsia Carson is a co-founder of Flat, www.flat.com, a New York City-based design firm. She is an accomplished interactive designer with an extensive background in visual culture. Her firm creates innovative solutions for a diverse set of clients. Projects include online, broadcast, print and product design. Carson was profiled in International Design Magazine's "ID's 40 Under 30" (40 influential designers under 30 years of age) in 2000. She is on the board of the NY Chapter of the AIGA and the Church of Craft. Carson is a lecturer at Yale in the graduate program for graphic design. She loves NY.

STEVE HARTMAN

STEVE HARTMAN

Creativille, St. Louis MO

Steve Hartman is founder of Creativille, Inc., a corporate communications firm. Hartman has spent ten years designing corporate print and web communications for various national and international companies. He has produced work for Helzberg Diamonds, Dillard's, The May Department Stores, International Truck, Argosy Gaming, Sprint, The St. Louis Zoo, The AIGA and Atrek Contemporary Dance Company. Hartman teaches at Washington University in St. Louis and has taught at the University of Missouri and at Webster University. The AIGA is a large focus as well, and he currently serves as development director of the AIGA St. Louis and has served as both president and vice president. On a national level, he serves on the Chapter Relief Fund committee and National Board Nominating committee, and is active in the AIGA Midwest mentor cluster. Hartman's work has been recognized by many award competitions.

DEBBIE MILLMAN

DEBBIE MILLMAN

Sterling Group, New York NY

Debbie Millman has been in the design business for the last 19 years working on numerous brand identity, advertising and creative accounts. As managing partner at Sterling Group, a leading marketing consultancy and brand identity firm, she directs all client services, sales and marketing for the firm, and oversees brand design for clients such as Gillette, Burger King, Kraft, Colgate-Palmolive, Pepsi-Cola, Campbells and Unilever. Currently, she is also the off-staff creative director for Emmis Broadcasting's Hot 97 radio station. Millman is the recipient of many awards, and is both a frequent lecturer as well as contributor to major trade magazines. She founded and chairs the annual Brand Identity Conference for the Institute of International Research, and is a past chair of the Marketing Leadership Council for the American Marketing Association. Prior to working at Sterling Group, Millman was a senior vice president at Interbrand and director of marketing at Frankfurt Balkind.

WENDY QUESINBERRY

WENDY QUESINBERRY

Quesinberry and Associates, Seattle WA

After transporting herself from sunny Florida to not-so-sunny Seattle in 1991, Wendy Quesinberry set up shop under the catchy moniker of Wendy Quesinberry Design. With that start, she spent time as art director for both *DanceNet* and *MovieMaker* magazines, as well as designer for several local ad agencies. After 11 years, the studio has grown from no office, no clients and no prospects to a multifaceted creative agency. In 2000, the company changed its name to Quesinberry and Associates (Q&A) to reflect this growth. Quesinberry, along with her associates, works with companies of all sizes on projects which range from anything print to motion graphics.

RODNEY REID

RODNEY REID
RLR Associates, Indianapolis IN

Rodney Reid is principal/creative director of Indianapolis-based RLR Associates, the environmental design firm he founded in 1988 to incorporate his diverse business experience. His career history includes: designer for a national engineering firm; art director for a general market advertising agency; and partner in a communications and advertising firm. RLR has designed exhibits and signage for the Chicago Museum of Science and Industry, the National FFA, the Mint Museum of Craft + Design, Conseco Fieldhouse, the Indianapolis Zoo, and the Indianapolis City Market. Reid attended Purdue University majoring in architectural engineering technology; he currently serves as a visiting professor. He also is coordinator of Nexgeneracers, a community youth motorsports program, and is active in the Society for Environmental Graphic Design.

IRASEMA RIVERA

IRASEMA RIVERA
Latina Media Ventures, New York NY

Irasema Rivera is the creative director for Latina Media Ventures, LLC, publishers of Latina magazine. She most recently led Latina's art department in redesigning the magazine, giving the publication a cleaner, more modern format. Her previous redesign of Latina was the winner of two national design awards. Rivera also worked with Hyperion to produce Latina's first beauty book and worked with Latina's web team to design Latina.com and Latinabeauty.com. Prior to serving at Latina, Rivera was design director at Disney/ABC's trade publishing division. She managed the graphic arts departments in New York City and Denver (executing over ten redesigns and four new launches) and worked with Disney's division in Mexico City to redesign Expansion, one of Mexico's leading consumer business publications. As a freelance consultant for her own studio, Big I Ranch Design, she works with clients on publication redesigns, corporate reports and a variety of other print and web projects.

MELITA SUSSMAN

MELITA SUSSMAN
Salomon Smith Barney, New York NY

Melita Sussman is first vice president/creative director at Salomon Smith Barney, New York, having served as a creative director with the company for the past 14 years. She oversees a graphic communications department responsible for designing marketing literature representing the firm. Projects range from brochures to annual reports. She holds a BFA and an MFA from Boston University.

PELEG TOP

PELEG TOP
Top Design Studio, Los Angeles CA

Principal and creative director Peleg Top celebrates more than ten years of design experience with his Los Angeles-based design firm. He started Top Design Studio out of his garage, and built it into one of the leaders in designing for the music and entertainment industries. Today some of his clients include The Grammy Awards, EMI Music, Universal, Disney and DreamWorks. Top shares his talents with the design community by providing marketing coaching to designers and creative firms across the country. He is active in the Southern California Chapter of the Graphic Artists Guild and was chair of the Grammy Awards CD packaging committee.

RAY UENO

RAY UENO
The Leonhardt Group, Seattle WA

Ray Ueno has been a member of The Leonhardt Group design team since 1990. Performing the function of chief creative officer, he provides vision for the firm's overall creative and establishes quality standards for work that continues to garner the highest awards in the industry. Ueno's experience ranges across a wide spectrum from branding/identity to naming, annual reports, packaging, digital movies and web sites. His work for Fisher Communications, Lifelong AIDS Alliance, Microsoft and InfoSpace are some of his favorite pieces. He has been recognized in virtually every top design awards publication.

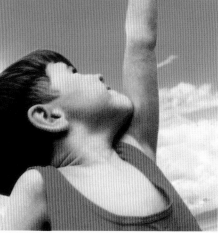

ANNUAL REPORTS

9

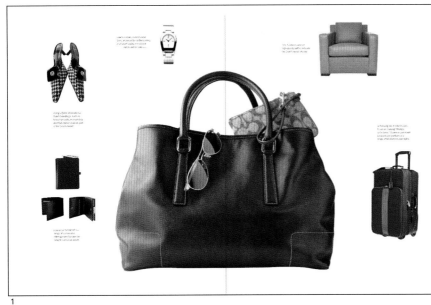

1

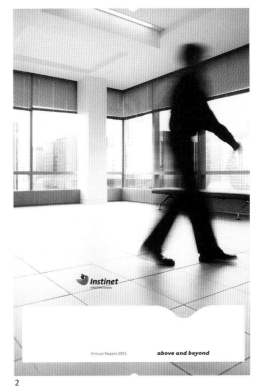

2

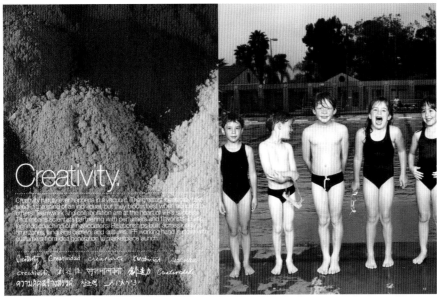

3

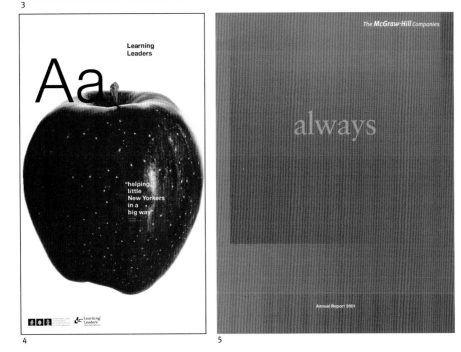

4

5

ANNUAL REPORTS

1 **Design Firm** Addison, New York NY
 Client Coach
 Title Annual Report
 Art Director David Kohler
 Designer Cindy Goldstein

2 **Design Firm** Addison, New York NY
 Client Instinet
 Title Annual Report
 Art Director David Kohler
 Designer Christina Antonopoulos
 Photographer Lorne Bridgman

3 **Design Firm** Addison, New York NY
 Client International Flavors & Fragrances Inc.
 Title Annual Report
 Art Director David Kohler
 Designer Simon Kennedy

4 **Design Firm** Addison, New York NY
 Client Learning Leaders
 Title Annual Report
 Designer Scott Galbraith
 Photographer Alison Rosa

5 **Design Firm** Addison, New York NY
 Client The McGraw-Hill Companies
 Title Annual Report
 Art Director David Kohler
 Designer Helen Steed
 Photographer Erika Larson

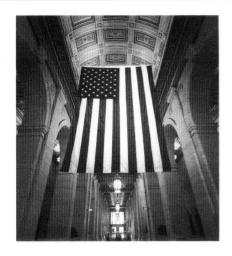

New York Life

Annual Report 2001

1

2

4

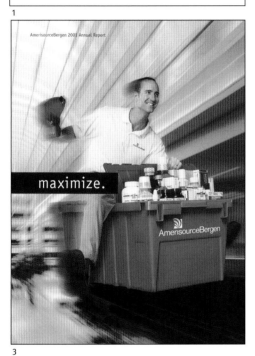

maximize.

AmerisourceBergen

3

Rural Telephone Finance Cooperative
ANNUAL REPORT

5

ANNUAL REPORTS

1 **Design Firm** Arnold Saks Associates, New York NY
Client New York Life
Title Annual Report
Art Director Arnold Saks
Designer Robert Yasharian
Photographer John Blaustein

2 **Design Firm** Arnold Saks Associates, New York NY
Client S.G. Cowen
Title Annual Report
Art Director Arnold Saks
Designer Robert Yasharian
Photographers Mark Tuschman, Bill Gallery, David Levenson

3 **Design Firm** art270, Inc., Jenkintown PA
Client AmerisourceBergen Corporation
Title Annual Report
Art Director Carl Mill
Designer Sue Strohm
Illustrator John Opet
Photographer Jerome Lukowicz

4 **Design Firm** Augustine Medical, Eden Prairie MN
Title Annual Report
Art Director Mike Miller
Designer Mike Miller
Photographer Kelly Shields Photography, Associated Press

5 **Design Firm** CFC/Rural Telephone Finance Cooperative, Herndon VA
Client Rural Telephone Finance Cooperative
Title Annual Report
Designer Jason Steiner
Photographer Rick McCleary

At Mercury, the fundamentals of our business are sound and have been from the day we wrote our first policy 40 years ago.

1

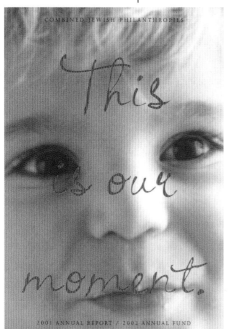

2

3

4

That's how the world looks when you're still growing up.

Kids Need a Kids' Hospital

5

ANNUAL REPORTS

1 **Design Firm** CMg Design Inc., Pasadena CA
Client Mercury General Corporation
Title Annual Report
Art Directors Julie Markfield, Greg Crawford
Designer Jean DeAngelis

2 **Design Firm** Combined Jewish Philanthropies, Boston MA
Title Annual Report
Art Directors Peter McDonald, Terry Holzman
Designer Peter McDonald
Photographers Joshua Dalsimer, Jim Thomas

3 **Design Firm** Computer Associates International, Inc., Islandia NY
Title Annual Report
Designer Loren Moss Meyer

4 **Design Firm** Edelman Design Worldwide, Chicago IL
Client Rockwell Collins, Inc.
Title Annual Report
Art Directors Teresa Costantini, Julia Allen
Designers Joe Ondrla, Julia Allen
Photographer Lazlo Bence

5 **Design Firm** EnZed Design, Denver CO
Client The Children's Hospital, Denver
Title Annual Report
Art Director Helen Young
Designer Helen Young
Illustrators Helen Young, Heather Haworth
Photographer Dan Knudson

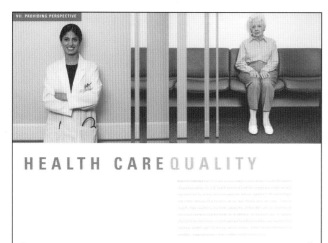

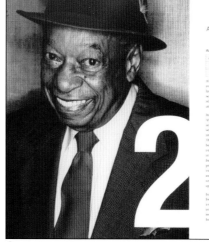

ANNUAL REPORTS

1 **Design Firm** Fathom Creative, Washington DC
Client AARP
Title Beyond 50 Report
Art Director Sheri Grant
Designers Dan Banks, Malia Dicksion, Drew Mitchell, Mike Ring

2 **Design Firm** Fathom Creative, Washington DC
Client AARP
Title Foundation Annual Report
Art Director Sheri Grant
Designers Sheri Grant, Malia Dicksion

3 **Design Firm** Fathom Creative, Washington DC
Client PFLAG
Title Annual Report
Art Director Sheri Grant
Designers Malia Dicksion, Dan Banks

4 **Design Firm** Foster Design Group, South Natick MA
Client Charles River Laboratories
Title Annual Report
Art Director Edwin Foster
Designers Ryan Wade, Sean Barklay
Photographer Len Rubenstein

5 **Design Firm** George-Gerard Design, Inc., New York NY
Client Columbia University College of Physicians & Surgeons
Title Pursuing Excellence
Art Director Hershell George
Designer Hershell George
Photographer Xavier Guardians

1 **Design Firm** Gill Fishman Associates, Cambridge MA
 Client Riverdeep Interactive Learning
 Title Annual Report
 Art Director Gill Fishman
 Designer Alicia Ozyjowski
 Photographer Ed Quinn

2 **Design Firm** Graphic Concepts, Inc., Miami FL
 Client HEICO Corporation
 Title Annual Report
 Art Director Jorge Barbery
 Designer Jorge Barbery
 Photographer J. Brian King

3 **Design Firm** HC Creative Communications, Bethesda MD
 Client Freddie Mac
 Title Annual Report
 Art Director Howard Clare
 Designer Jessica Vogel
 Photographer Mark Segal

4 **Design Firm** HC Creative Communications, Bethesda MD
 Client The Washington Post Company
 Title Annual Report
 Art Director Howard Clare
 Designer Ann Marie Ternullo
 Photographer Robert Burke

5 **Design Firm** Ideas on Purpose, New York NY
 Client NYCE
 Title Annual Report
 Art Director Michelle Marks
 Illustrator Anja Kroencke

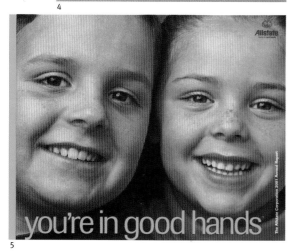

ANNUAL REPORTS

1 **Design Firm** Im-aj Communications & Design, Inc., West Kingston RI
 Client Rhode Island Children's Crusade
 Title Answering the Question
 Art Director Jami Ouellette
 Designers Jami Ouellette, Mark Bevington
 Photographers Jonathan Flynn, Mark Bevington

2 **Design Firm** JB Communications, Santa Rosa CA
 Client American AgCredit
 Title A Country Album
 Art Director Randy Chet
 Designers Octane Design
 Illustrator Randy Chet

3 **Design Firm** Liquid Agency Inc., San Jose CA
 Client Santa Clara County Girl Scouts of America
 Title Annual Report
 Art Director Lisa Kliman
 Creative Director Alfredo Muccino
 Designers Lisa Kliman, Jennifer Larsen
 Photographer Mark Leet

4 **Design Firm:** Mashtun Creative, Boston MA
 Client Partners In Housing Development Corporation
 Title Putting the Pieces Together
 Art Director Jason Wallengren
 Designer Jason Wallengren
 Photographer Stephen W. Hill

5 **Design Firm:** Meta-4 Design, Inc., Chicago IL
 Client Allstate Corporation
 Title Annual Report
 Art Director Jan Gulley
 Designers Jan Gulley, Eugine Casis
 Illustrator Eugine Casis
 Photographer Paul Elledge

Youth Opportunities United

2001-02

Annual Report

A Comprehensive Strategy uniting the community to meet the needs of our youth.

1

Historic Preservation

10

2

Getting It Done
A RECORD OF SUCCESS

Annual Report 2001

New York City Economic Development Corporation

3

transplant resource center
of Maryland 2000 Annual Report

4

EVERY DAY
in the Chinese beauty industry
300,000 SQUARE FEET OF
COSMETICS

ARE PURCHASING ENOUGH TO GIVE
TWO MILES OF THE
GREAT WALL OF CHINA
A MAKEOVER

NU SKIN

5

ANNUAL REPORTS

1 **Design Firm** Morehead, Dotts & Associates, Corpus Christi TX
Client Youth Opportunities United
Title Annual Report
Art Director Mo Morehead
Designer Gilbert Cantu

2 **Design Firm** New Jersey Housing and Mortgage Finance Agency, Trenton NJ
Title Annual Report
Designer Ana Maria Rivera-Pramuk
Photographer James Shive

3 **Design Firm** New York City Economic Development Corporation, New York NY
Title Getting It Done - A Record of Success
Art Director Randi Press
Designer Randi Press

4 **Design Firm** nfgd, Baltimore MD
Client Transplant Resource Center of Maryland
Title Annual Report
Art Director Nick Foudos
Designer Nick Foudos

5 **Design Firm** Nu Skin Enterprises, Inc., Provo UT
Title Are You Sitting Down?
Art Director Mark Patterson
Designer Mark Patterson
Illustrator Megan Duncan
Photographer John Wang

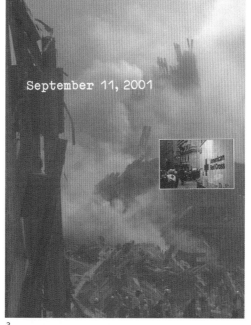

September 11, 2001

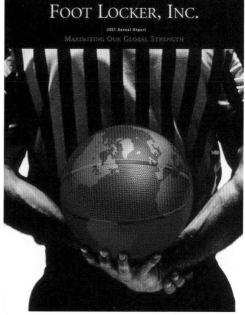

SAVING MEMORIES

ALZHEIMER'S ASSOCIATION
2001 ANNUAL REPORT

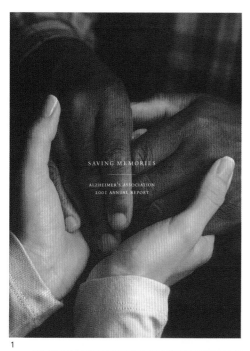

FOOT LOCKER, INC.

2001 Annual Report
MAXIMIZING OUR GLOBAL STRENGTH

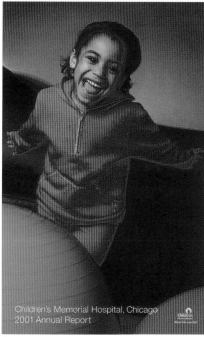

Children's Memorial Hospital, Chicago
2001 Annual Report

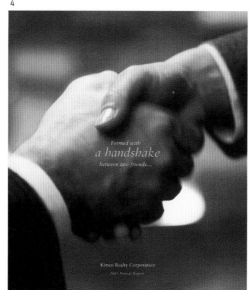

Formed with
a handshake
between two friends...

Kimco Realty Corporation
2001 Annual Report

ANNUAL REPORTS

1 **Design Firm** Pivot Design, Inc., Chicago IL
Client Alzheimer's Association
Title Annual Report
Art Director Brock Haldeman
Designers Don Emery,
Jennifer Stortz
Photographer Tony Armour

2 **Design Firm** Pivot Design, Inc., Chicago IL
Client Children's Memorial Hospital, Chicago
Title Annual Report
Art Director Brock Haldeman
Designer Jennifer Stortz
Photographer Jeff Sciortino

3 **Design Firm** Roher/Sprague Partners,
Irvington NY
Client American Red Cross in Greater New
York
Title Annual Report
Art Director Melanie Roher
Designers Melanie Roher,
Christine Sturmer

4 **Design Firm** RWI, New York NY
Client Foot Locker, Inc.
Title Annual Report
Designer Michael DeVoursney

5 **Design Firm** RWI, New York NY
Client Kimco Realty Corporation
Title Annual Report
Designer Linda Chen
Photographer Preston Lyon

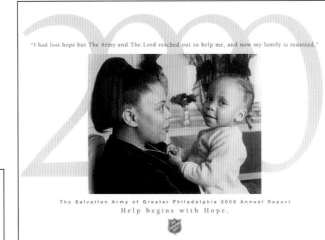

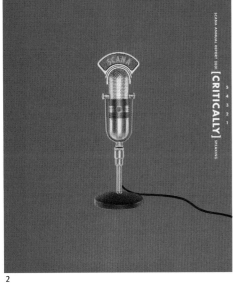

Focus on life

Bio-Technology General Corp.
2001 Annual Report

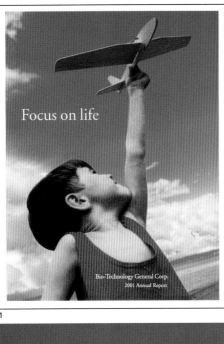

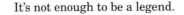

It's not enough to be a legend.

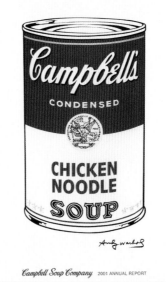

Campbell's
CONDENSED

CHICKEN
NOODLE
SOUP

Andy Warhol

Campbell Soup Company 2001 ANNUAL REPORT

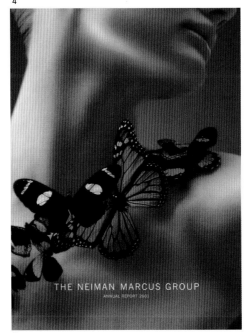

THE NEIMAN MARCUS GROUP
ANNUAL REPORT 2001

ANNUAL REPORTS

1 **Design Firm** Sara Bernstein Design, Brooklyn NY
Client Bio-Technology General Corp.
Title Focus on Life
Art Director Sara Bernstein
Designer Sara Bernstein
Photographer James Rudnick

2 **Design Firm** Scana Corporation, Columbia SC
Client Investor Relations
Title Critically Speaking
Art Director Lee Price
Designer Lee Price
Photographer George Fulton

3 **Design Firm** Scott Design Communications, Philadelphia PA
Client The Salvation Army
Title Annual Report
Art Director Helene Krasney
Designer Helene Krasney
Photographer Candace diCarlo

4 **Design Firm:** Sequel Studio, New York NY
Client Campbell Soup Company
Title Annual Report
Art Director Brett Gerstenblatt
Designer Dana Gonsalves

5 **Design Firm** Sequel Studio, New York NY
Client The Neiman Marcus Group
Title Annual Report
Art Director Brett Gerstenblatt
Designer Dana Gonsalves

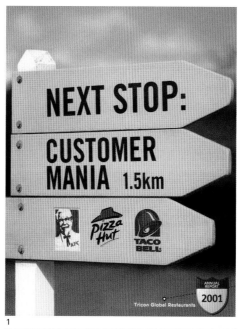

ANNUAL REPORTS

1 **Design Firm** Sequel Studio, New York NY
Client Tricon Global Restaurants
Title Next Stop: Customer Mania
Art Director Steve Mignogna
Designers Dana Gonsalves, Bazil Findlay
Photo Illustration Matthew Baldwin
Photographers Andy Goodman, Joe McNally, Brian Smith

2 **Design Firm** Stan Gellman Graphic Design, St. Louis MO
Client LaBarge Inc.
Title Annual Report
Art Director Barry Tilson
Designer Erin Goter
Photographer Greg Kiger

3 **Design Firm** Stan Gellman Graphic Design, St. Louis MO
Client UniGroup, Inc.
Title Annual Report
Art Director Teresa Thompson
Designer Jill Lampen
Photographer Greg Kiger

4 **Design Firm** Stephen Burdick Design, Boston MA
Client Boston Parks and Recreation Department
Title Annual Report
Art Director Stephen Burdick
Designer Stephen Burdick
Photographer C. Elena Houghton

5 **Design Firm** Stephen Burdick Design, Boston MA
Client Wainwright Bank & Trust Company
Title Annual Report
Art Director Stephen Burdick
Designer Stephen Burdick
Illustrator Bonnie Acker
Photographer David du Busc

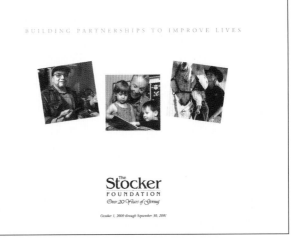

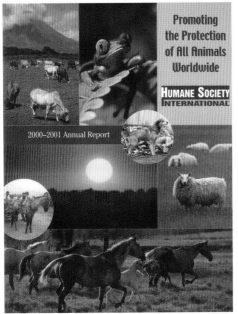

1

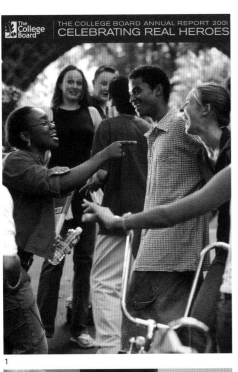

2

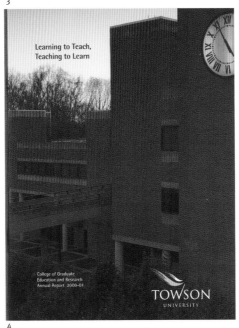

3

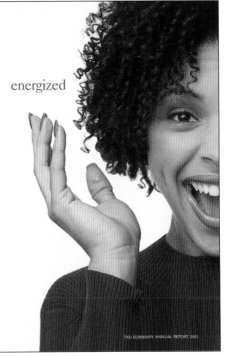

4

5

ANNUAL REPORTS

1 **Design Firm** The College Board, New York NY
Title Annual Report
Art Director Roger Gorman
Designer Roger Gorman
Photographer Daniel Miller Photography

2 **Design Firm** The Humane Society of the
United States, Gaithersburg MD
Title Promoting the Protection of All
Animals Worldwide
Art Director Paula Jaworski
Designer Elizabeth McNulty

3 **Design Firm** The Shamrock Companies Inc.,
Westlake OH
Client The Stocker Foundation
Title Annual Report
Art Director John Bennett
Designer Lori Leiter

4 **Design Firm** Towson University, Towson MD
Title College of Graduate Education and
Research Annual Report
Art Director Rick Pallansch
Designer Rick Pallansch

5 **Design Firm** TXU Corp., Dallas TX
Client TXU Energy
Title Energized: TXU Summary Annual Report
Art Director Marcus Dickerson
Designers Eisenberg and Associates
Photographers Stewart Cohen, Jon Love

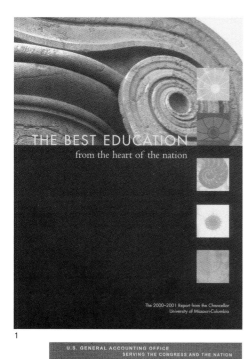

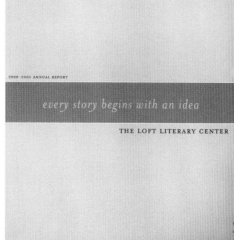

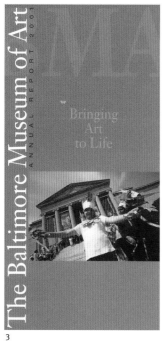

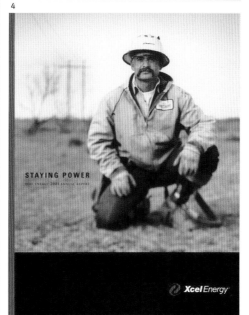

ANNUAL REPORTS

1 **Design Firm** University of Missouri Publications, Columbia MO
Client Prospective Donors
Title MU Annual Report
Art Director Josh Nichols
Photographers Rob Hill, Steve Morse

2 **Design Firm** U.S. General Accounting Office, Washington DC
Client GAO
Title Performance and Accountability Highlights
Art Director Orlando Boston
Designers Mimi Nguyen, Barbara Hills
Photographer Richard Rockburn

3 **Design Firm** whiteSTARdesign, Bethlehem PA
Client The Baltimore Museum of Art
Title Annual Report
Art Director Peter Stolvoort
Designer Peter Stolvoort

4 **Design Firm** Yamamoto Moss, Minneapolis MN
Client The Loft Literary Center
Title Annual Report
Art Director Alan Tse
Designer Kim Welter

5 **Design Firm** Yamamoto Moss, Minneapolis MN
Client Xcel Energy
Title Staying Power
Art Director Joan Frenz
Designers Joan Frenz, Kim Welter
Photographer Joe Treleven

ADVERTISING

22

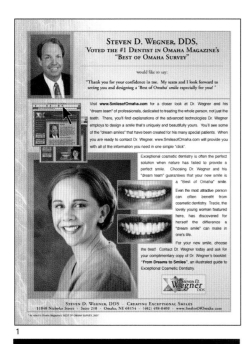

1

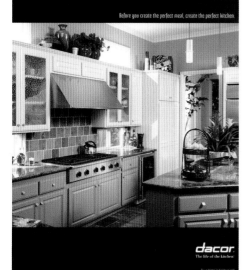

2

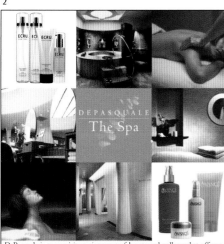

3

4

5

ADVERTISING

1 **Design Firm** Curtis Marketing Group, St. Joseph MN
 Client Stephen D. Wegner, DDS
 Title Best of Omaha
 Designer Bret Wieseler

2 **Design Firm** Dacor Distinctive Appliances, Inc.,
 Pasadena CA
 Client Dacor
 Title Part Gladiator
 Art Director Brent Spann
 Designer Chris Murdzak
 Illustrator Judy Bruce
 Photographer Tom Hollar

3 **Design Firm** DePasquale Companies, Fairlawn NJ
 Client DePasquale - The Spa
 Title Vogue Magazine Ad
 Art Director Heather Bancroft
 Designer Heather Bancroft

4 **Design Firm** Erbe Design, South Pasadena CA
 Client Henry Blackham Photography
 Title Ad Series
 Art Director Maureen Erbe
 Designers Maureen Erbe, Efi Latief
 Photographer Henry Blackham

5 **Design Firm** G2, New York NY
 Client Brown and Williamson Tobacco Corporation
 Title Silhouette
 Art Director Kirk Gayle
 Designer Kirk Gayle
 Illustrator Beverly Gibbs
 Photographer Steve Lesnick

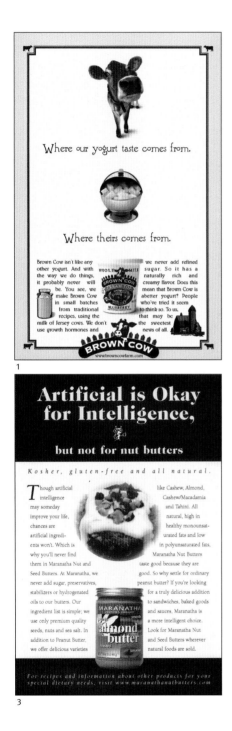

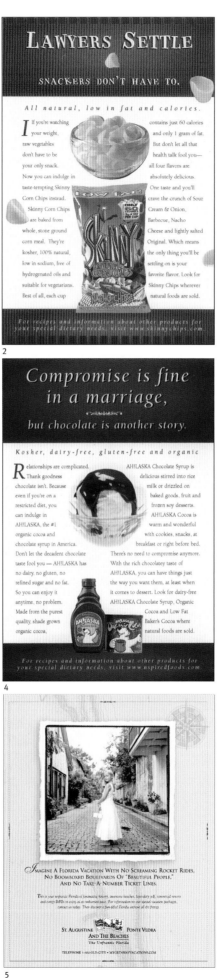

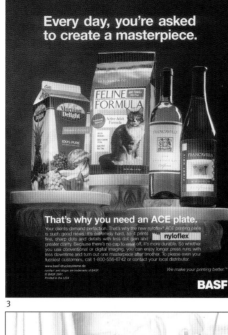

Every day, you're asked to create a masterpiece.

FELINE FORMULA

That's why you need an ACE plate.

Your clients demand perfection. That's why the new nyloflex® ACE printing plate is such good news. It's extremely hard, so it prints fine, sharp dots and details with less dot gain and greater clarity. Because there's no cap to wear off, it's more durable. So whether you use conventional or digital imaging, you can enjoy longer press runs with less downtime and turn out one masterpiece after another. To please even your fussiest customers, call 1-800-556-6742 or contact your local distributor.

www.basf-drucksysteme.de
nyloflex® and slogan are trademarks of BASF
© BASF 2001
Printed in the USA

We make your printing better.™

BASF

3

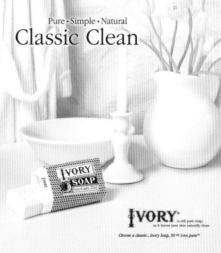

Pure · Simple · Natural

Classic Clean

IVORY SOAP

IVORY® is still pure soap, so it leaves your skin naturally clean.

Choose a classic...Ivory Soap, 99 44/100% pure™

4

2.8 BILLION BOTTLES OF BEER ON THE WALL

2.8 billion emails are served up every day—a number growing by 150% a year. Today, emails are an overwhelming source of evidence. When you need to gather, extract and organize electronic data, DataTrail delivers—in the format you request.

E-DISCOVERY SEMINAR
Get control of the electronic discovery process with DataTrail by attending our seminar. (3 CLE credits have been requested.) Registration is free.

Tuesday, July 24
9:00 a.m.–1:00 p.m.
JW Marriott Hotel
1331 Pennsylvania Ave. NW

Lunch will be served.

Visit www.ontrack.com/dccle for details. To register, call 703.821.8211 by July 18.

Can't join us?
Let us bring the seminar to you. Call for details.

DATATRAIL IN WASHINGTON
Contact us at 703.821.8211 or visit www.ontrack.com/dc.

Ontrack
DATATRAIL
Electronic Discovery Solutions

1

2.8 BILLION EMAILS SENT IN 2001

E-DISCOVERY SEMINAR
Get control of the e-discovery process with DataTrail by attending our seminar. (2 CLE credits have been requested.) Registration is free.

Tuesday, July 24
9:00 a.m.–1:00 p.m.
JW Marriott Hotel
1331 Pennsylvania Ave. NW

Lunch will be served.

Visit www.ontrack.com/dccle for details. To register, call 703.821.8211

Can't join us?
Let us bring the seminar to you. Call for details.

DATATRAIL IN WASHINGTON
Contact us at 703.821.8211 or visit www.ontrack.com/dc.

Ontrack
DATATRAIL
Electronic Discovery Solutions

2

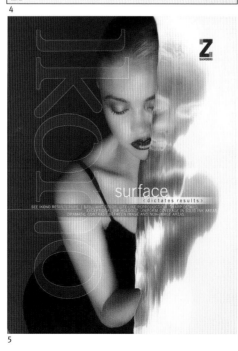

surface
‹ dictates results ›

Z ZANDERS

SEE IKONO RESULTS HERE | BRILLIANT COLOR, LIFE-LIKE REPRODUCTION | SHARP DETAIL, EXCEPTIONAL INK HOLDOUT, UNIFORM COVERAGE IN SOLID INK AREAS | DRAMATIC CONTRAST BETWEEN IMAGE AND NON-IMAGE AREAS

5

ADVERTISING

1 **Design Firm** Greenfield/Belser Ltd., Washington DC
Client OnTrack DataTrail
Title Bottles Ad
Art Director Burkey Belser
Designer Burkey Belser

2 **Design Firm** Greenfield/Belser Ltd., Washington DC
Client OnTrack DataTrail
Title Tachometer Ad
Art Director Burkey Belser
Designer Burkey Belser

3 **Design Firm** Howell Design, Inc., Williamsburg VA
Client BASF Printing Systems
Title Ad Campaign
Art Director Kathy Howell
Designer Ben Griffon
Photographer Bill Boxer

4 **Design Firm** Interbrand Hulefeld, Cincinnati OH
Client Procter & Gamble
Title Classic Clean - Ivory Print Ad
Art Director Tom Tekulue
Designer Jodi Sena
Illustrator Ken Kirby
Photographer Steve Pazst

5 **Design Firm** NDW Communications, Horsham PA
Client M-real
Title Surface-Insert for Zanders Ikono
Art Director Bill Healey
Designer Bill Healey
Photographer Howard Schatz

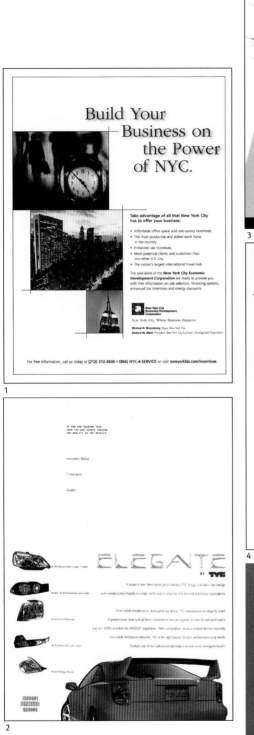

Build Your Business on the Power of NYC.

Take advantage of all that New York City has to offer your business:

- Affordable office space and cost-saving incentives.
- The most productive and skilled work force in the country.
- Enhanced tax incentives.
- More potential clients and customers than any other U.S. city.
- The nation's largest international travel hub.

The specialists at the **New York City Economic Development Corporation** are ready to provide you with free information on site selection, financing options, enhanced tax incentives and energy discounts.

New York City Economic Development Corporation

New York City. Where Business Happens.

Michael R. Bloomberg, Mayor, New York City
Andrew M. Alper, President, New York City Economic Development Corporation

For free information, call us today at (212) 312-3600 • (866) NYC-4-SERVICE or visit newyorkbiz.com/incentives

1

ELEGANTE by TYC

2

a style that is right for you and nobody else
it's your style.
guaranteed

Kenneth Wildes
S A L O S
www.kwsalons.com

9 Beacon Place • Newton, MA • 617.964.2077 | 214 Route 1 • Rainbow Square • Westwood, MA • 781.329.3033

3

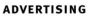 intentia

The marketplace has evolved.

You have to adapt to survive.
Do you know what it takes?

it takes intentia

Enterprise Operations • Supply Chain • CRM • Collaboration

Today's business environment no longer supports yesterday's ways of thinking. Survival means finding a trusted partner you can turn to for answers. Intentia is helping companies transition to successful business models that meet the demands of this new market, and the results are nothing short of amazing.

Intentia has the experience, the industry knowledge, and the technological expertise to streamline your business processes and give you the competitive edge you need. When you're looking for strategy, solutions, and support, turn to Intentia.

please visit us at intentia.com
or call 1.800.SW.MOVEX

4

5

movers and shakers

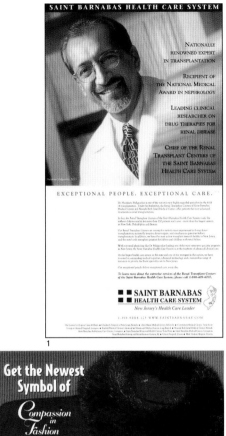

1

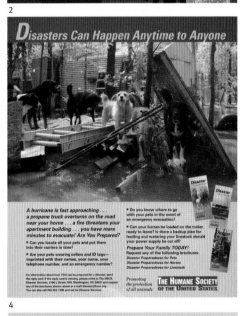

2

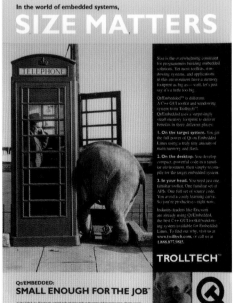

4

3

5

ANNOUNCEMENTS/CARDS

28

1

2

3

The Diabetes Summit:
A New Patient Treatment Regimen
in Cardiovascular Disease

A MULTISPONSORED CME SYMPOSIUM
Saturday, November 10, 2001
The Hilton Anaheim and Towers
Pacific Ballroom D
Anaheim, California

Bridge the gap between science and medicine at this
unabridged symposium regarding treatment strategies for
diabetic patients with cardiovascular disease. From the
basics of genomics of diabetes to formulary options, learn
both the scientific and clinical aspects of patient care to
this CME summit.

12:15 pm – 12:55 pm Lunch Buffet
12:55 pm – 4:30 pm Scientific Session

Sponsored by Medical Media Communications, Inc.

4

5

ANNOUNCEMENTS/CARDS

1 **Design Firm** Addis, Berkeley CA
 Client Planned Parenthood Golden Gate
 Title Gala Poster
 Art Director Nancy Hoefig
 Designer Monica Schlaug

2 **Design Firm** Archetype Group Inc.,
 Green Bay WI
 Client Newist
 Title Activate to Illuminate
 Art Director James Rivett
 Designers Robb Mommaerts, Jason Davis
 Photographer Kris Maz

3 **Design Firm** Artisa LLC, Plainsboro NJ
 Client Cotsen Children's Library,
 Princeton University
 Title Seen & Heard Conference Materials
 Art Director Isabella D. Palowitch
 Designer Isabella D. Palowitch
 Illustrator Isabella D. Palowitch
 Photographers John J. Blazejewski,
 Ross Stout

4 **Design Firm** Asylum, Skokie IL
 Client Medical Media Communications, Inc.
 Title Symposium Invitation
 Art Director Ron Klein
 Designer Ron Klein

5 **Design Firm** BD&E, Pittsburgh PA
 Client Neurofibromatosis Clinics
 Association
 Title Fundraising Premium
 Art Director Cheryl Bender
 Designer Cheryl Bender
 Photographer Harry Giglio

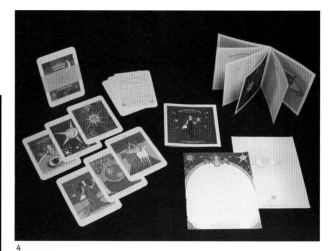

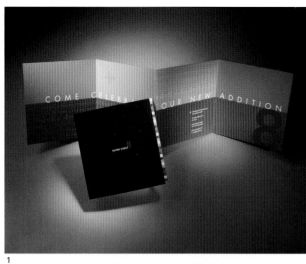

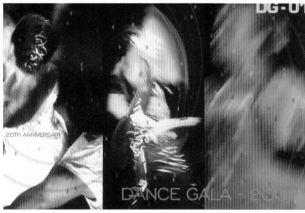

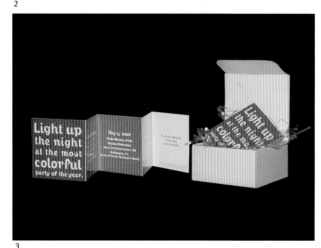

ANNOUNCEMENTS/CARDS

1 **Design Firm** Belyea, Seattle WA
 Client ColorGraphics
 Title Super8 Announcement
 Art Director Patricia Belyea
 Designer Ron Lars Hansen
 Photographer Dan Taylor, Studio 360

2 **Design Firm** Benson & Hepker Design, Iowa City IA
 Client University of Iowa Dance Department
 Title Dance Gala-2001
 Art Director Robyn Hepker
 Designer Carol Palmer

3 **Design Firm** Bloomberg, New York NY
 Client Bloomberg News
 Title Correspondents' Dinner
 Art Director Sandy O'Connor
 Designer Holly Tienken

4 **Design Firm** Bloomberg, New York NY
 Client The Central Park Conservancy
 Title Halloween Ball Invite
 Art Director Sandy O'Connor
 Designer Ali Jeffery
 Illustrator Ali Jeffery

5 **Design Firm** Bloomberg, New York NY
 Client The New York Historical Society
 Title History Makers Gala 2001
 Art Director Sandy O'Connor
 Designer Holly Tienken
 Photographer The Chase Collection

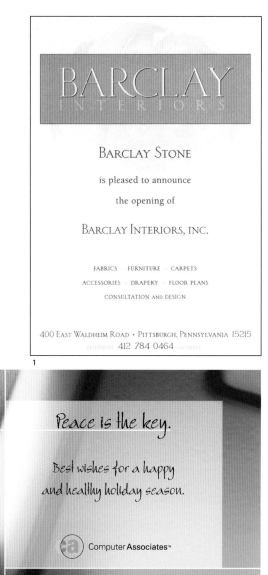

1

4

2

3

5

ANNOUNCEMENTS/CARDS

1 **Design Firm** Carl Chiocca, Creative Designs, Pittsburgh PA
 Client Barclay Interiors
 Title Opening Announcement
 Art Director Carl Chiocca

2 **Design Firm** Computer Associates International, Inc.,
 Islandia NY
 Title Holiday Card
 Designer Jennifer Mariotti Williams

3 **Design Firm** Dart Design, Fairfield CT
 Client Brody Printing
 Title Holiday Cards
 Art Director David Anderson
 Designer Tracie Valentino

4 **Design Firm** EC Design, Hackettstown NJ
 Client Coldwell Banker Commercial
 Title Global Commercial Conference Invitation
 Designer Kristin Levitskie

5 **Design Firm** Eryn Willard, Frederick MD
 Client Eryn and Chris Willard
 Title Wedding Invitation
 Art Directors Eryn and Chris Willard
 Designer Eryn Willard

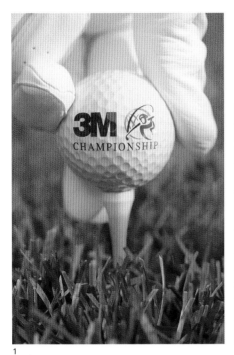

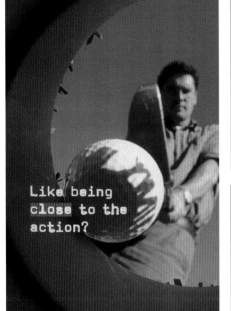

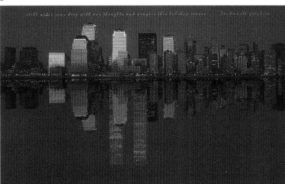

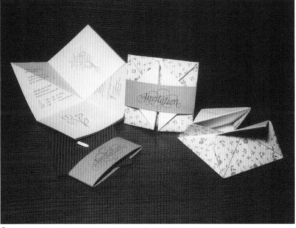

1 **Design Firm** Franke and Fiorella,
Minneapolis MN
Client 3M
Title Championship Invitation
Art Director Craig Franke
Designer Richard Ketelsen

2 **Design Firm** Gee + Chung Design,
San Franscisco CA
Client Applied Materials
Title Seminar Invitations
Art Director Earl Gee
Designers Fani Chung, Earl Gee
Photographer Nick Veasey

3 **Design Firm** John Kallio
Graphic Design, New Haven, CT
Client Connecticut Business and
Industry Association
Title GHO Invitation
Art Director John Kallio
Designer John Kallio

4 **Design Firm** Loudmouth Graphics,
Venice CA
Title Still Water Holiday Card
Art Director David Schroer
Designer David Schroer
Illustrator David Schroer

5 **Design Firm** Lynn Cyr Design,
Franklin MA
Title Party Invitation
Designer Lynn Cyr

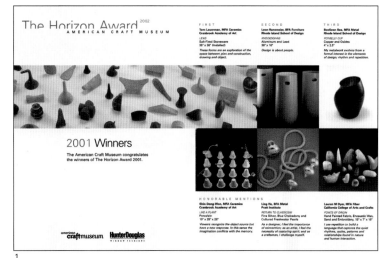

1

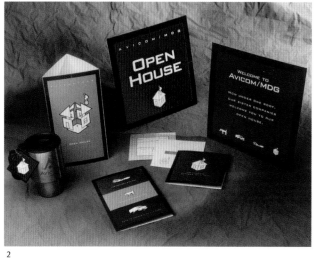

2

3

4

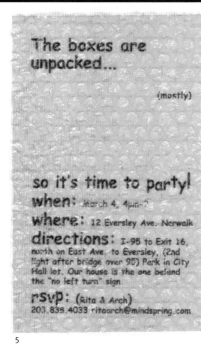

5

ANNOUNCEMENTS/CARDS

1 **Design Firm** M. Novak Design, New York NY
Client The American Craft Museum
Title The Horizon Award
Art Director Michelle Novak
Designers Jae Barclay, Ciara Bartlett, Maggie Campalong

2 **Design Firm** McCulloch Design Group, Waukesha WI
Client Avicom/MDG
Title Moving Announcement/Open House
Art Director Ted Mayer
Illustrator Ted Mayer

3 **Design Firm** Nassar Design, Brookline MA
Client Leers Weinzapfel Associates
Title Announcements
Art Director Nelida Nassar
Designer Margarita Encomienda
Photographer Esto

4 **Design Firm** New York City Economic Development Corporation,
New York NY
Title Holiday Card
Art Director Randi Press
Designer Cintra Parsons

5 **Design Firm** No Left Turn, Norwalk CT
Client Rita Muncie and Arch Currie
Title Housewarming Invitation
Art Director Rita Muncie
Designer Rita Muncie

1

2

3

4

5

6

ANNOUNCEMENTS/CARDS

1 **Design Firm** Noon, San Francisco CA
Client Greg Shove
Title Baby Announcement
Art Director Cinthia Wen
Designer Cinthia Wen

2 **Design Firm** Octavo Designs, Frederick MD
Client Linda And John Morgan
Title Double Treasures
Art Director Sue Hough
Designers Eryn Willard, Sue Hough
Illustrator Eryn Willard
Photographer Mark Burrier

3 **Design Firm** p11creative, Santa Ana Heights CA
Client Orangewood Childrens Foundation
Title Bringin' It Home Invitation
Creative Director Lance Huante
Designer Mike Esperanza
Illustrator Leigh White

4 **Design Firm** Piderit, New York NY
Title Wrap Session Holiday Card
Art Director Richard Mehl
Designer Sheila Elkins

5 **Design Firm** Plato Learning Inc., Bloomington MN
Title Train for the Future
Art Director Chad Mattson
Designer Tanya Krohn

6 **Design Firm** Raytheon Technical Services Co., Burlington MA
Client Raytheon Media Solutions
Title Sea-Air-Space Invite
Art Director Cynthia Lucier
Designer Cynthia Lucier

1

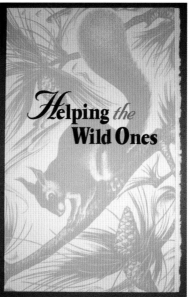

2

3

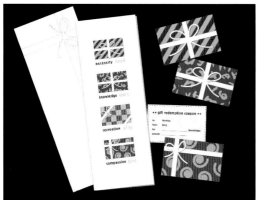

4

5

ANNOUNCEMENTS/CARDS

1 **Design Firm** Southern Company, Atlanta GA
Client Christy Terrell, Southern Company Energy Marketing PR Manager;
Doug Jones, Camma Curle, Southern Company Energy Marketing
Title The Winter Games Hospitality
Art Director Vicki Gardocki
Designer Kelli Stoudenmire Jones
Photographer Jay Harris, Printing Rep.

2 **Design Firm** The Humane Society of the United States, Gaithersburg MD
Title Helping the Wild Ones
Art Director Paula Jaworski
Designer Paula Jaworski

3 **Design Firm** Towers Perrin, Southfield MI
Title Market Manager Announcement
Art Director Rebecca Deason
Designer Rebecca Deason
Photographer Dave Frechette

4 **Design Firm** US Motivation, Atlanta GA
Client Diebold
Title Tierra de los Conquistadores
Designer Kylie Dayton

5 **Design Firm** Vivian Lai Design, San Francisco CA
Client Greg Rule Production (Big Brothers/Big Sisters)
Title Christmas Card
Art Director Vivian Lai
Designer Vivian Lai

6 **Design Firm** Yamamoto Moss, Minneapolis MN
Client Fraser
Title Fund Raising Invite
Art Director Joan Frenz
Designer Hiroshi Watanabe
Illustrator Hiroshi Watanabe

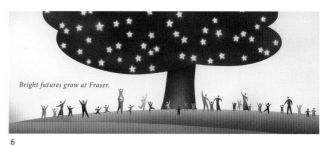

6

BROCHURES/COLLATERAL

36

1

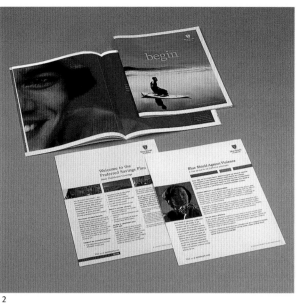

2

3

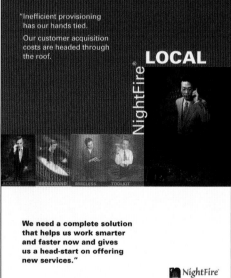

5

4

1 **Design Firm** Adam, Filippo & Associates, Pittsburgh PA
Client Promistar Financial
Title Trust Brochure
Art Directors Robert Adam, Ralph James Russini
Designers Martin Perez, Larry Geiger

2 **Design Firm** Addis, Berkeley CA
Client Blue Shield of California
Title Blue Shield Collateral
Art Director John Cueson
Designers Monica Schlaug, Michael Knaggs

3 **Design Firm** Addison, New York NY
Title Capabilities Brochure
Art Director Brian Collentine
Designer Robin Awes

4 **Design Firm** AElliott Design, Burke VA
Client National Association of Real Estate Investment Trusts
Title Nareit Reports
Art Director Amanda Elliott
Designer Amanda Elliott

5 **Design Firm** Agreda Communications, Eureka CA
Client NightFire Software, Inc.
Title Collateral System
Art Director Jim Nelson
Designer Jim Nelson
Illustrator Matthew Livesey

1

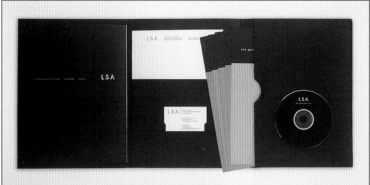

2

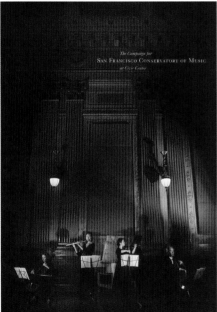

3

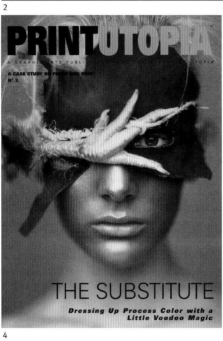

4

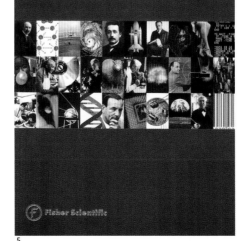

5

BROCHURES/COLLATERAL

1 **Design Firm** AJF Marketing, Piscataway NJ
 Client International Flavors & Fragrances Inc.
 Title FlexiMint Collateral Material
 Art Director Justin Brindisi
 Designer Justin Brindisi

2 **Design Firm** Alterpop, San Francisco CA
 Client LSA
 Title Presentation Package
 Art Director Doug Akagi
 Designer Kimberly Powell

3 **Design Firm** Alterpop, San Francisco CA
 Client San Francisco Conservatory of Music
 Title Case Statement
 Art Director Dororthy Remington
 Designer Jennifer Andreoni
 Photographer Jeffrey Newbury

4 **Design Firm** Appleton Coated, Kimberly WI
 Title Print Utopia 3 - The Substitute
 Designer Yelton Design

5 **Design Firm** Arnold Saks Associates,
 New York NY
 Client Fisher Scientific
 Title A Century of Discovery and Innovation
 Art Director Arnold Saks
 Designer Robert Yasharian

BROCHURES/COLLATERAL

1 **Design Firm** Asylum, Skokie IL
Client Radiological Society of North America
Title 2002 Advance Registration
Art Director William Current
Designer Jay Vidheecharden
Illustrator Jay Vidheecharden
Photographers Ron Klein, William Current

2 **Design Firm** Augustine Medical,
Eden Prairie MN
Title Ranger Smart Heat Brochure
Art Director Mike Miller
Designer Mike Miller
Illustrator Bob Klein
Photographer Engstrom Photography

3 **Design Firm** Aurora Design, Niskayuna NY
Client Mohawk Paper Mills, Inc.
Title Mohawk Show Brochure
Designer Jennifer Wilkerson
Illustrator Dennis Ichiyama

4 **Design Firm** Baltimore Area Convention and
Visitors Association, Baltimore MD
Title Folder, Binder, Tabs, DPG Cover
Art Director Georganne Cammarata
Designers Georganne Cammarata,
Dee Drees (cover design)

5 **Design Firm** Barnett Design, Inc., Ramsey NJ
Client The Community Foundation for
Bergen County
Title Plant a Seed Brochure
Art Director Debra Barnett Sagurton
Designer Jefferson Ramos

1

2

4

5

1

2

3

4

5

BROCHURES/COLLATERAL

1 **Design Firm** Barnett Design, Inc., Ramsey NJ
Client Concept Printing, Inc.
Title Red Button Store Brochure
Art Director Debra Barnett Sagurton
Designer Jefferson Ramos

2 **Design Firm** Barnett Design, Inc., Ramsey NJ
Client Foundation for the Advancement of
Cardiac Therapies
Title FACT Brochure
Art Director Debra Barnett Sagurton
Designer Jefferson Ramos

3 **Design Firm** BBK Studio, Inc., Grand Rapids MI
Client ABC West Michigan Auto Auction
Title Capabilities Overview
Art Director Sharon Oleniczak
Designer Michele Chartier
Photographer Andy Terzes

4 **Design Firm** BD&E, Pittsburgh PA
Client Carnegie Mellon
Title GSIA Recruitment Package
Art Director Cheryl Bender
Designer Cheryl Bender
Photographer Harry Giglio

5 **Design Firm** BD&E, Pittsburgh PA
Client University of Pittsburgh School of
Medicine
Title Recruitment Viewbook
Art Director Ed Macko
Designers Susan Limoncelli, Ed Macko
Photographers Kevin Gregory, David Aschkenas

BROCHURES/COLLATERAL

1 **Design Firm** Benjamin Moore & Co., Montvale NJ
Title The 2002 Marketing Plan
Art Director Louis Simeone
Designer Louis Simeone
Photographer Peter Iannone

2 **Design Firm** BI, Minneapolis MN
Client 5/3 Bank
Title Go All Out
Creative Director Emily Ganzel
Art Director Mark Geis
Illustrator Stephanie Carter

3 **Design Firm** BI, Minneapolis MN
Client Amgen
Title Power of Perfomance
Creative Director Mary Rita Balogh
Designer John Federoff
Illustrator Roberta Polfus

4 **Design Firm** BI, Minneapolis MN
Client Sun Microsystems
Title Sun Tech Days
Creative Director: Leeanne Huber
Art Director Mark Geis

5 **Design Firm** Black Diamond Concepts, Denver CO
Client Crestone International
Title Sales Folder
Art Director Dan Bahn
Designer Ben Larson

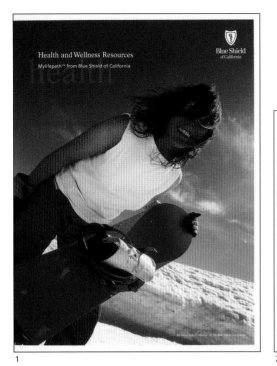

BROCHURES/COLLATERAL

1 **Design Firm** Blue Shield of California,
San Francisco CA
Title Mylifepath Programs and
Services Brochure
Art Director Stephanie Donahue
Designer Larissa Nahhas

2 **Design Firm** Brad Terres Design,
Pleasanton CA
Client Essex Property Trust, Inc.
Title Hillsborough Park Brochure
Designer Brad Terres
Illustrator Matt Meehan

3 **Design Firm** Brandesign Incorporated,
Monroe NJ
Client Walnut Asset Management
Title Corporate Brochure
Art Director Barbara Harrington
Designer Barbara Harrington
Illustrator Ed Mullowney
Photographer Susan Beard

4 **Design Firm** Brown & Company Design,
Portsmouth NH
Client Suncook Trim
Title Brochure
Art Director David Markovsky
Designers Andrea Adams,
David Markovsky

5 **Design Firm** CAG Design,
Hackettstown NJ
Title Brochure
Designer CAG Design

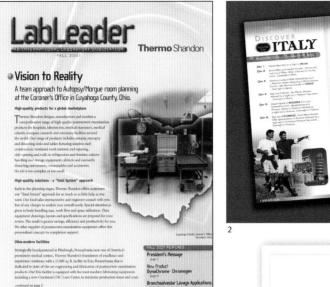

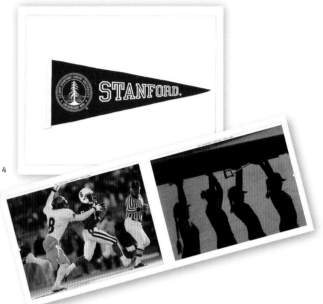

BROCHURES/COLLATERAL

1 **Design Firm** Carl Chiocca, Creative Designs, Pittsburgh PA
Client Thermo Shandon
Title Fall 2001 LabLeader
Art Director Carl Chiocca

2 **Design Firm** Casale Design, Inc., New York NY
Client Pride International
Title Travel Brochure
Designer George T. Casale
Copywriter Rami Rosen

3 **Design Firm** Cisneros Design, Inc., Santa Fe NM
Client SITE Santa Fe
Title Youth Guide
Art Director Brian Hurshman
Designer Brian Hurshman
Photographer Chris Corrie

4 **Design Firm** Clark Creative Group, San Francisco CA
Client Stanford University Athletic Department
Title The Stanford Cardinal 1990-2000
Art Director Annemarie Clark
Designer Noreen Rei Fukumori
Photographer David Gonzalez

5 **Design Firm** Clean Slate, Denver CO
Client Intelliden
Title Sales Folder
Designer John Lopes
Illustrator John Lopes

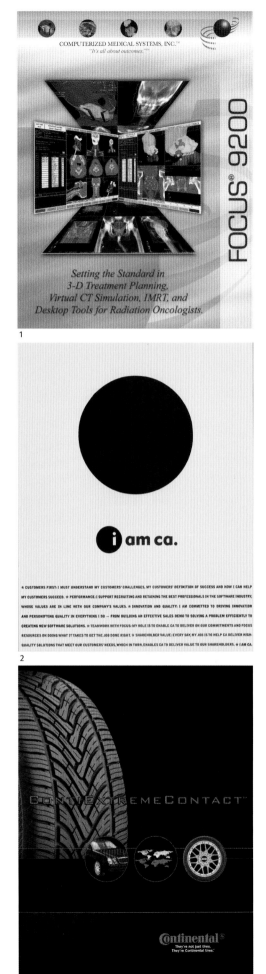

1

SOLUTIONS FOR THE FUTURE

Union of Concerned Scientists
Citizens and Scientists for Environmental Solutions

4

2

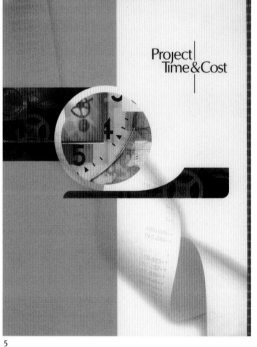

Project Time&Cost

5

1 **Design Firm** CMS, Inc., St. Louis MO
Title Focus 9200
Art Director Dennis Setchfield
Designer Dennis Setchfield

2 **Design Firm** Computer Associates International, Inc., Islandia NY
Title Core Values Brochure
Art Director Loren Moss Meyer
Designer Loren Moss Meyer
Illustrator Tom White

3 **Design Firm** Concentric Marketing, Charlotte NC
Client Continental Tire North America, Inc.
Title ContiExtremeContact
Art Director Mary Dichito
Designer Jason Clewell

4 **Design Firm** Concept Foundry, Bethesda MD
Client Union of Concerned Scientists
Title Solutions for the Future
Art Director Susan Walston
Designer Monica Banko

5 **Design Firm** Crawford/Mikus Design, Inc., Atlanta GA
Client Project Time & Cost
Title Brochure
Art Director Elizabeth Crawford
Designer Elizabeth Crawford
Illustrator Elizabeth Crawford

3

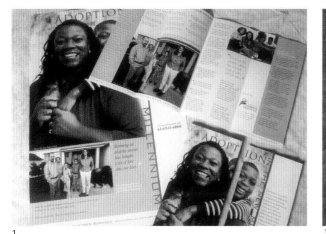

1

3

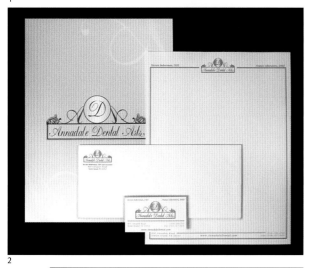

2

4

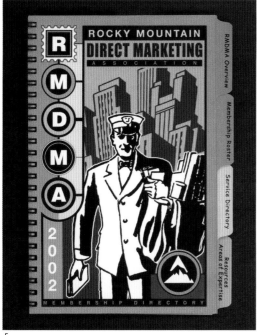

5

BROCHURES/COLLATERAL

1 **Design Firm** Creative Design Solutions, Columbus OH
Client Franklin County Children Services
Title Children Services Adoption
Art Director Chris Schweitzer
Designer Chris Schweitzer

2 **Design Firm** Curtis Marketing Group, St. Joseph MN
Client Annadale Dental Arts
Title Corporate Identity
Designer Jason Puffe
Photographer Stewart Lorenz

3 **Design Firm** Danek! Graphic Design, Holyoke MA
Client GE Financial Assurance
Title GE Choices
Art Director Anne Dietrich
Designer John M. Danek

4 **Design Firm** Design Source East, Cranford NJ
Title dse/b®andesign Brochure
Art Director Mark LoBello
Designer Mark LoBello

5 **Design Firm** Eagleye Creative, Littleton CO
Client Rocky Mountain Direct Marketing Association
Title Membership Directory
Art Director Steve Schader
Designer Steve Schader

BROCHURES/COLLATERAL

1 **Design Firm** Edelman Design Worldwide,
 Chicago IL
 Client Microsoft
 Title Winter Wonderland Media Kit
 Art Directors Julia Allen, Teresa Costantini
 Designer Julia Allen

2 **Design Firm** Edward Jones Advertising
 Department, St. Louis MO
 Client Internal
 Title Product Brochure
 Art Director Brian Hopwood
 Designer Jill Halpin
 Editor Nancy Mack
 Writer Colleen Raley

3 **Design Firm** Energy Energy Design,
 Los Gatos CA
 Client ProTrials
 Title Corporate Brochure
 Art Director Leslie Guidice
 Designers Stacy Guidice, Jeanette Aramburu

4 **Design Firm** Epstein Design Partners, Inc.,
 Cleveland OH
 Client Dance Cleveland
 Title 2002-2003 Season Brochure
 Designer Brian Jasinski

5 **Design Firm** Erbe Design,
 South Pasadena CA
 Client Motorola Life Sciences
 Title eSensor System-Product Brochure
 Art Director Maureen Erbe
 Designers Maureen Erbe, Rita Sowins
 Photographer Henry Blackham

1

4

2

3

5

BROCHURES/COLLATERAL

1 **Design Firm** Fathom Creative, Washington DC
 Client Iris Alliance Fund
 Title Corporate Brochure
 Designers Sheri Grant, Dan Banks

2 **Design Firm** Fidelity Investments, Marlborough MA
 Client Fidelity Plan Sponsors
 Title EGTRRA Guide/EGTRRA Amendments
 Art Director Susan Girard
 Designer Amanda Milks
 Copywriter Kieran Sullivan

3 **Design Firm** Fidelity Investments, Marlborough MA
 Client University Hospitals of Cleveland
 Title Collateral Materials
 Designer Linda Lodi

4 **Design Firm** G & O Design, Inc., Los Angeles CA
 Client Nova by Gruber
 Title 2002 Mailer
 Art Director Gillian Gough
 Designer Nat Skaphusith

5 **Design Firm** Gee + Chung Design, San Franscisco CA
 Client ComVentures
 Title The Future of Communications
 Art Directors Earl Gee, Fani Chung
 Designers Fani Chung, Earl Gee, Kay Wu
 Photographer Henrik Kam

1

4

2

5

3

BROCHURES/COLLATERAL

1 **Design Firm** Gee + Chung Design,
San Franscisco CA
Client Xinet, Inc.
Title Workflow Solutions
Art Director Earl Gee
Designers Fani Chung, Earl Gee
Photographer Kevin Irby

2 **Design Firm** Gill Fishman Associates,
Cambridge MA
Client American Arbitration Association
Title Alternative Dispute Resolution
Vision Roundtable
Art Director Gill Fishman
Designer Dori Smith

3 **Design Firm** Glick Design, Kahului HI
Client Grand Wailea Resort
Title Kulana Club Brochure
Designer Robert Glick

4 **Design Firm** Glick Design, Kahului, HI
Client Olowalu Associates
Title Brochure
Designer Robert Glick
Photographer Robert Glick

5 **Design Firm** Gomersall Design,
Santa Barbara CA
Client Parks & Recreation
Community Foundation
Title Brochure
Art Director Dianne Gomersall
Designers Dianne Gomersall,
Mimi Mowery
Photographers Tamara Graff, Kathleen
Sullivan, Ashley R. Sanchez, Santa
Barbara Trust for Historic Preservation

1

2

BROCHURES/COLLATERAL

1 **Design Firm** Gomersall Design, Santa Barbara CA
 Client Santa Barbara County Parks
 Title Facility Guide
 Art Director Dianne Gomersall
 Designers Dianne Gomersall, Mimi Mowery

2 **Design Firm** Greenfield/Belser Ltd., Washington DC
 Client Cozen O'Connor Attorneys
 Title Insurance Brochure
 Art Director Burkey Belser
 Designer John Bruns

3 **Design Firm** Greenfield/Belser Ltd., Washington DC
 Client Wolf Greenfield & Sacks
 Title Firm Brochure
 Art Directors Burkey Belser, Charlyne Fabi
 Designers Charlyne Fabi, Janet Morales
 Illustrator James Yang

4 **Design Firm** Greenhouse Design, Highland Park NJ
 Client Omega
 Title Omega DeVille
 Art Director Miriam Grunhaus
 Designer Miriam Grunhaus

5 **Design Firm** Griffith Phillips Creative, Dallas TX
 Client Datamax Texas
 Title Materials
 Art Director Brian Niemann
 Designer Brian Niemann

5

3

4

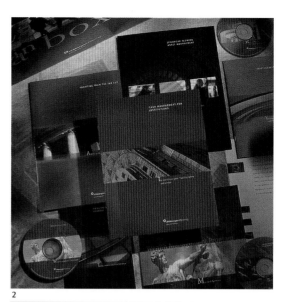

1

2

3

4

5

BROCHURES/COLLATERAL

1 **Design Firm** Hanlon Brown Design,
Portland OR
Client Marshall Wells Lofts
Title Small Brochure
Art Director Sandy Brown
Designer Theresa Kosztics
Photographer Jeff Krausse Photography

2 **Design Firm** Hanson Associates,
Philadelphia PA
Client JPMorgan Fleming
Title Wealth Management Program
Art Director Tobin Beck
Designer Lisa Brueggemann

3 **Design Firm** Harvard University,
Cambridge MA
Client Harvard University
Dining Services
Title Dining at Harvard
Designers Brent Hale, Crista Martin
Illustrators Brent Hale, Crista Martin

4 **Design Firm** Household International
Employee Communications,
Prospect Heights IL
Client Household Consumer Lending
Title Consumer Lending Leadership
Conference Agenda
Art Director Chris Tomsic
Designer Bob Zwolinski
Illustrator Steve Gooud

5 **Design Firm** Household International
Employee Communications,
Prospect Heights IL
Client Household Employees
Title United for Hope Brochure
Art Director Chris Tomsic
Designer Bob Zwolinski

1

2

3

BROCHURES/COLLATERAL

1 **Design Firm** ICON Imaging Studios, Costa Mesa CA
Client Saleen, Inc.
Title Saleen S7 Brochure
Designer Broesel Design
Illustrator Erich Broesel
Production Artist Cyndy Geier

2 **Design Firm** iDesign, Seymour CT
Client Readi-Bake, Inc.
Title SYSCO Block & Barrel Cookies
Creative Director Lisa Viarengo
Art Director Nicole Fitzgerald
Designer Nicole Fitzgerald
Project Manager Lisa Viarengo
Copywriter Lisa Viarengo
Photographer Jon Van Gorder, Van Gorder Studios, Inc.

3 **Design Firm** iDesign, Seymour CT
Client Readi-Bake, Inc.
Title Readi-Bake-The Biscuit Bunch
Creative Director Lisa Viarengo
Art Director Nicole Fitzgerald
Designer Nicole Fitzgerald
Project Manager Lisa Viarengo
Copywriter Lisa Viarengo
Photographer Jon Van Gorder, Van Gorder Studios, Inc.

4 **Design Firm** IFA, Miami FL
Client International Franchise Association
Title Franchising World February/March 2002
Art Director Catherine Marinoff
Designer Catherine Marinoff

5 **Design Firm** Ilium Associates, Inc., Bellevue WA
Client Trammell Crow Residential
Title The Bay Court at Harbour Pointe Leasing Brochure
Art Director Don Sellars
Designer Angela Hopkins

4

5

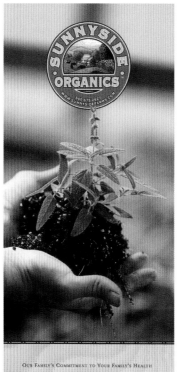

BROCHURES/COLLATERAL

1 **Design Firm** Integrity Graphic Design,
New Hartford NY
Client Serenity Farm-Farm Market
Title Mail Order Brochure
Art Director Linda A. Zielinski
Designer Linda A. Zielinski
Illustrator Linda A. Zielinski
Photographer Patricia Lawson

2 **Design Firm** Integrity Graphic Design,
New Hartford NY
Client Utica First Insurance Company
Title Slip & Fall Brochure
Art Director Linda A. Zielinski
Designer Linda A. Zielinski
Illustrator Linda A. Zielinski

3 **Design Firm** Janet Hughes and Associates,
Wilmington DE
Client Ausimont USA
Title Opening Doors
Art Director Peter Stolvoort
Designer Peter Stolvoort

4 **Design Firm** JDC Design, Inc., New York NY
Client Edelman Public Relations
Title FAP Folder
Art Director Jeff Conway
Designer Valentina Kogan

5 **Design Firm** JDG Communications, Inc.,
Falls Church VA
Client Sunnyside Organics, LLC
Title Our Family's Commitment to
Your Family's Health
Designers JDG Team
Illustrator Rolando Perdigon
Photographer Randy Santos

1

2

4

3

5

BROCHURES/COLLATERAL

1 **Design Firm** Jeffrey Leder Inc., New York NY
Title Brochure
Art Director Jeffrey Leder
Designer Steven Albarracin

2 **Design Firm** Jones Design Group, Atlanta GA
Client Geographics
Title 10-Color Press Brochure
Art Director Vicky Jones
Designer Caroline McAlpine
Photographer Davies & Lawery

3 **Design Firm** Jones Design Group, Atlanta GA
Client Graphic Response
Title Capabilities Brochure
Art Director Vicky Jones
Designer Brody Boyer

4 **Design Firm** Kittner Design, Takoma Park MD
Client Sellery Associates, Inc.
Title Capabilities Package
Art Director Bobbi Kittner
Designers Bobbi Kittner, Tai Hoover,
Kristin Kaineg
Photographer Sam Kittner

5 **Design Firm** kor group, Boston MA
Client eCopy
Title Brochure
Art Director Karen Dendy
Designer Jim Gibson
Photographer Anton Grassl

BROCHURES/COLLATERAL

1 **Design Firm** kor group, Boston MA
 Client eCopy
 Title Nine Times Out of Ten Binder
 Art Director Anne Callahan
 Designer James Grady
 Photographer Anton Grassl

2 **Design Firm** kor group, Boston MA
 Client Manulife Capital Corporation
 Title Brochure
 Art Director MB Jarosik
 Designer James Grady

3 **Design Firm** Langton Cherubino Group,
 New York NY
 Client Pearson
 Title Benefits Package
 Art Director David Langton
 Designer Jim Keller

4 **Design Firm** M. Novak Design, New York NY
 Client Hirtle, Callaghan & Co.
 Title Corporate Brochure
 Art Director Michelle Novak
 Designer Michelle Novak
 Photographer Per Bernsten

5 **Design Firm** Mashtun Creative, Boston MA
 Client Stephen Charles Photography
 Title The Difference is Art
 Art Director Jason Wallengren
 Designer Jason Wallengren
 Photographer Dan Roggi

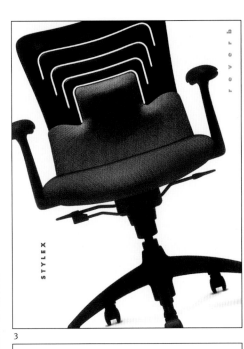

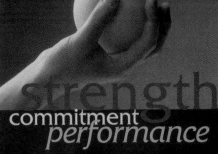

The Planning Vision

2

tower hill school multa bene facta

4

2002 MEDIA KIT

Desktop Engineering

desketg.com

- analysis
- cad/cam
- data acquisition
- fea/cfd
- pdm/plm
- rapid prototyping
- workstations
- collaboration tools

○ TARGET THE COLLABORATIVE DESIGN ENGINEERING TEAM

A Helmers Publication

5

BROCHURES/COLLATERAL

1 **Design Firm** Mason Design, Simsbury CT
Client Integrated Rehabilitation Services
Title strength, commitment, performance
Art Director Ken Mason
Designer Ken Mason

2 **Design Firm** Michael Gunselman
Incorporated, Wilmington DE
Client Longwood Gardens
Title Long Range Master Plan, Staff Version
Art Director Michael Gunselman
Designer Michael Gunselman
Photographer Michael Gunselman

3 **Design Firm** Michael Gunselman
Incorporated, Wilmington DE
Client Stylex
Title Product Brochure Series
Art Director Michael Gunselman
Designer Michael Gunselman
Photographer Tom Crane

4 **Design Firm** Michael Gunselman
Incorporated, Wilmington DE
Client Tower Hill School
Title View Book
Art Director Michael Gunselman
Designer Michael Gunselman
Photographers Bill Denison, Kevin Fleming,
Michael Gunselman

5 **Design Firm** Moonshadow Design,
Greenville NH
Client Desktop Engineering Magazine
Title 2002 Media Kit
Designer April Walker

1

2

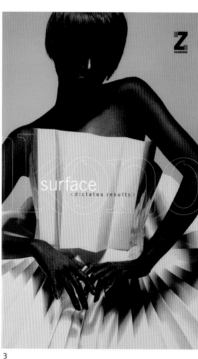

3

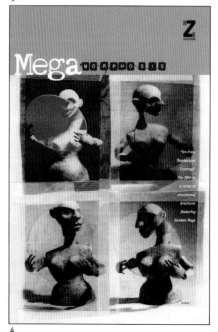

4

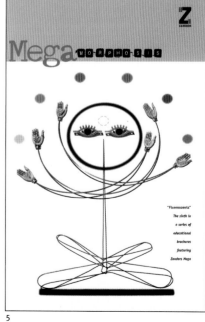

5

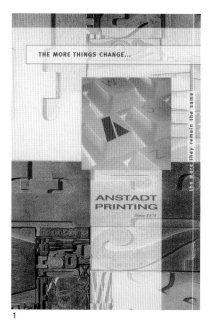

1

2

3

4

5

1 **Design Firm** nfgd, Baltimore MD
 Client Anstadt Printing
 Title The More Things Change...
 Art Director Nick Foudos
 Designer Nick Foudos

2 **Design Firm** Noevir U.S.A., Inc., Irvine CA
 Title Brochure
 Art Director Joseph Gaydos
 Designers Joseph Gaydos, Rene Armenta
 Photographer Greg Porter

3 **Design Firm** Norasack Design, Alexandria VA
 Client Star Remote Wireless
 Title Pocket Folder
 Designer Norasack Pathammavong

4 **Design Firm** Norasack Design, Alexandria VA
 Client Webrizon
 Title Pocket Folder
 Designer Norasack Pathammavong

5 **Design Firm** Northeastern University
 Publications, Boston MA
 Client Office of Admissions
 Title Acceptance Package
 Art Director Mary Beth McSwigan
 Designer Jessica Schindhelm
 Photographer Len Rubenstein

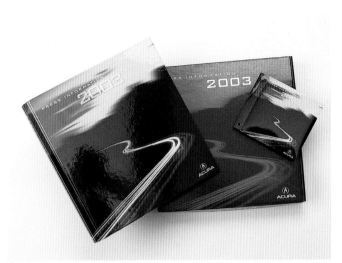

1

2

3

4

5

BROCHURES/COLLATERAL

1 **Design Firm** Oakwood DC, Manhattan Beach CA
 Client Acura
 Title 2003 Press Kit
 Creative Director Rick DeLome
 Designer Linda Ganzini

2 **Design Firm** Oakwood DC, Manhattan Beach CA
 Client Acura
 Title 2003 3.2 CL Press Kit
 Creative Director Rick DeLome
 Designers Alan Fisher, Linda Ganzini

3 **Design Firm** Oakwood DC, Manhattan Beach CA
 Client Honda
 Title Honda Pilot Press Kit
 Creative Director Rick DeLome
 Designer Linda Ganzini

4 **Design Firm** P Green Design, Ambridge PA
 Client Renaissance City Winds
 Title Elegant Music in Intimate Spaces Season Brochure
 Art Director Paulette Green
 Designer Paulette Green
 Illustrator Paulette Green
 Photographer Tara Alexander

5 **Design Firm** p11creative, Santa Ana Heights CA
 Client 1st Annual Orange County Poetry Festival
 Title Brochure
 Creative Director Lance Huante
 Designer Alex Chao

1

4

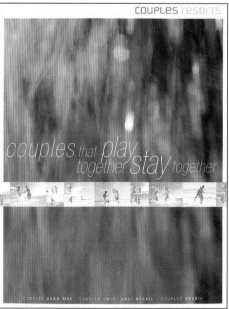

2

BROCHURES/COLLATERAL

1 **Design Firm** Parker Hannifin Corp., Cleveland OH
Title WE Book/Brochure
Art Director Dave Grager
Designer Dave Grager

2 **Design Firm** Petertil Design Partners, Oak Park IL
Client Village of Skokie
Title Economic Development Brochure
Art Director Kerry Petertil
Designer Kerry Petertil
Photographer Paul Doughty

3 **Design Firm** Pinkhaus, Miami FL
Client Couples Resorts
Title Brochure
Art Director Todd Houser
Designer Raelene Mercer
Production Manager Suzanne Bernstein
Copywriter Frank Cunningham
Photographer David Harry Stewart

4 **Design Firm** Pivot Design, Inc., Chicago IL
Client The Feinberg School of Medicine- Northwestern University
Title Viewbook
Art Director Brock Haldeman
Designer Jill Misawa
Photographer Jim Ziv

5 **Design Firm** Plato Learning Inc., Bloomington MN
Title Spring Mailer Campaign
Art Director Chad Mattson
Designer Jennifer Stricker
Copywriter Steve Brantner

3

5

1

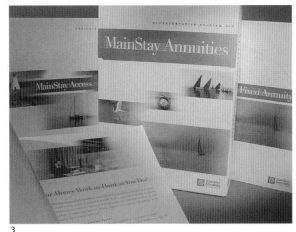

3

4

2

5

BROCHURES/COLLATERAL

1 **Design Firm** Premier Communications
Group, Inc., Royal Oak MI
Client GM Hummer
Title 2003 Hummer H2 Press Kit
Art Director Peter Pultz
Designer CD-Joe Becker

2 **Design Firm** PriceWaterhouseCoopers,
New York NY
Client CEOs and CFOs of Major
Global Corporations
Title Entering the United States
Securities Markets
Art Director Raquella Kagan
Designer Raquella Kagan

3 **Design Firm** PrimeLook, Inc., New York NY
Client MainStay Annuities
Title Representative Selling Kit
Art Director Sally Hiesiger
Designer Sally Hiesiger

4 **Design Firm** PrimeLook, Inc., New York NY
Client Travelers Life & Annuity
Title Growing a Legacy Kit
Art Director Sally Hiesiger
Designer Sally Hiesiger

5 **Design Firm** ProQuest Information and
Learning, Ann Arbor MI
Client HeritageQuest Online
Title Mini Brochure
Art Director Mark Howell
Designer Bethany Leiter
Writer Mary Kay Murray

1

2

3

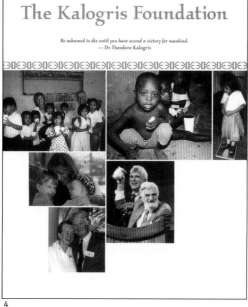

4

5

1

2

4

5

BROCHURES/COLLATERAL

1 **Design Firm** Signature Communications,
Philadelphia PA
Client PMA Reinsurance
Title Corporate Brochure
Art Director Darren Hoffman
Designer Darren Hoffman

2 **Design Firm** Stan Gellman Graphic Design,
St. Louis MO
Client Hope Meadows
Title Hope for the Future
Art Director Barry Tilson
Designer Erin Goter
Photographer Caroline Greyshock

3 **Design Firm** Studio/Lab Chicago, Chicago IL
Client Mohawk Paper Co.
Title Mohawk Options
Art Director Marcia Lausen
Designers Sharon Oiga, Ricki Hill, Jill Hoffheimer,
Kristin Gurnitz

4 **Design Firm** Studio/Lab Chicago, Chicago IL
Client Morningstar Investment Services
Title Product Launch Kit
Art Director Ana Schedler
Designers Ana Schedler, Tara Kennedy,
Meeyoung Medamed, Kristin Gurnitz
Photographer Jean Noel Reichel

5 **Design Firm** StudioNorth, North Chicago IL
Client Allegiance Healthcare Corporation
Title Eyescape Opthalmic Drapes Brochure
Art Director Laura Campbell
Designer Allison Misevich
Illustrator Steve Herberger
Writer Dan Gutknecht

1

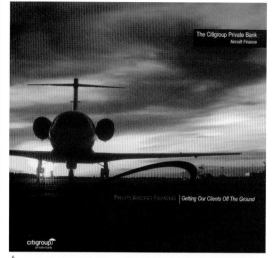

4

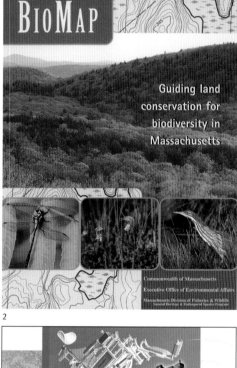

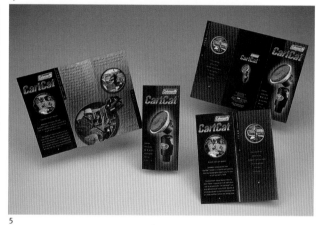

2

3

BROCHURES/COLLATERAL

1 **Design Firm** StudioNorth, North Chicago IL
 Client Allegiance Healthcare Corporation
 Title SmartGown Brochure
 Art Director Laura Campbell
 Designer Laura Campbell
 Illustrator Steve Herberger
 Writer Dan Gutknecht
 Photographer Brian Beaugureau

2 **Design Firm** Sullivan Creative, Watertown MA
 Client Massachusetts Division of Fisheries and Wildlife
 Title BioMap
 Art Director Chuck Provancher
 Designers Chuck Provancher, Elizabeth Gebler
 Photographer Massachusetts Division of Fisheries and Wildlife

3 **Design Firm** The Art Group Inc., Raleigh NC
 Client Buhler Motor, Inc.
 Title Case In Point
 Art Director Shane Poteete
 Designer Shane Poteete
 Illustrator Shane Poteete
 Photographer Ray Strawbridge, 21st Century Scientific, Inc.

4 **Design Firm** The Citigroup Private Bank, New York NY
 Title Private Aircraft Financing
 Designer Dado Lam

5 **Design Firm** The Coleman Company, Inc., Wichita KS
 Title CartCat Brochure
 Art Director Mat Cornejo
 Senior Designer Carrie Barnes
 Photographers Steve Gerig, Paul Chauncey

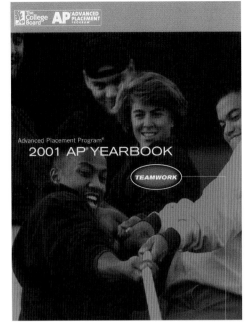

1

3

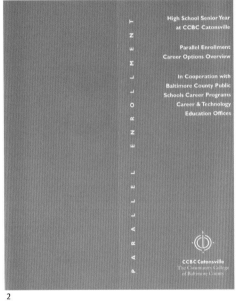

2

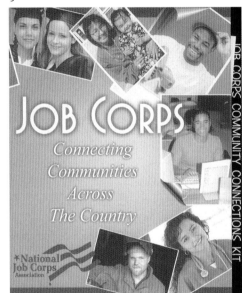

4

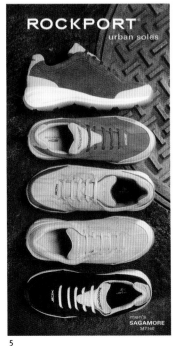

5

BROCHURES/COLLATERAL

1 **Design Firm** The College Board, New York NY
 Title 2001 AP Yearbook
 Art Director Roger Gorman
 Designer Roger Gorman

2 **Design Firm** The Community College of
 Baltimore County, Baltimore MD
 Title Parallel Enrollment Brochure
 Art Director Public Relations
 Designer Meg McKinley

3 **Design Firm** The Community College of
 Baltimore County, Baltimore MD
 Title Health Careers Brochure
 Art Director Public Relations
 Designer Meg McKinley

4 **Design Firm** The Leonard Resource
 Group, Inc., Alexandria VA
 Client National Job Corps Association
 Title NJCA Community Connections Kit
 Art Director Alex Dale
 Designer Alex Dale
 Illustrator Alex Dale
 Photographer Chris Kuhn

5 **Design Firm** The Rockport Company,
 Canton MA
 Title Urban Soles
 Art Director Beth Kerner
 Designer Doug Beswick
 Illustrator Doug Beswick
 Photographer Vincent Noe/
 Indresano Photography

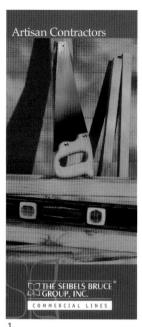

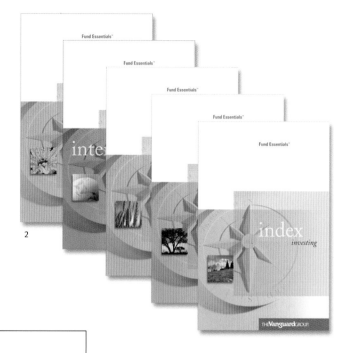

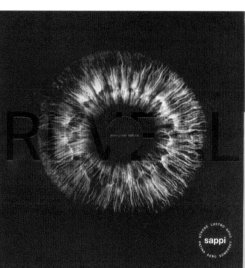

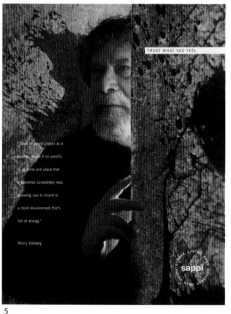

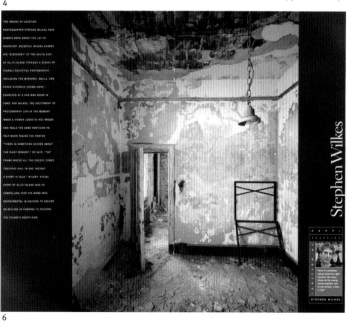

BROCHURES/COLLATERAL

1 **Design Firm** The Seibels Bruce Group, Inc.,
Columbia SC
Client Seibels Bruce Commercial Lines
Title Product Brochures
Art Director Amy Kulp
Designer Ward Bates

2 **Design Firm** The Vanguard Group, Inc.,
Valley Forge PA
Title Fund Essentials Series
Art Director Brad Kear
Designer Margo Borten

3 **Design Firm** The Vanguard Group, Inc.,
Valley Forge PA
Title Change of Ownership Brochure
Art Director Brad Kear
Designer Felix Toussaint

4 **Design Firm** Toth Brand Imaging,
Concord MA
Client Sappi Fine Paper North America
Title Reveal
Designer Kimberlee Danton
Copywriter Stephen Romano

5 **Design Firm** Toth Brand Imaging,
Concord MA
Client Sappi Fine Paper North America
Title Visionary
Designer Robert Cipriani
Copywriter Stephen Romano
Photographer Frank Ockenfels

6 **Design Firm** Toth Brand Imaging,
Concord MA
Client Sappi Fine Paper North America
Title Ignition Volume #1
Designer Robert Cipriani
Copywriter Stephen Romano

1

2

Graduate to
a higher level of content.

Better news
Better photos
Better graphics

Better than ever.

TMS Campus has become
KRT Campus — it's everything
you loved about TMS Campus
and more.

KRT campus™
www.krtcampus.com

3

4

5

BROCHURES/COLLATERAL

1 **Design Firm** Towson University, Towson MD
 Title International Portfolio
 Art Director Mike Dunne
 Designer Keith Matthews
 Photographer Kanji Takeno

2 **Design Firm** Tribune Media Services, Chicago IL
 Title Commentators Brochure
 Designer Stephani Kuehn

3 **Design Firm** Tribune Media Services, Chicago IL
 Client KRT Campus
 Title Brochure
 Designer Ji Sook Kim

4 **Design Firm** Tribune Media Services, Chicago IL
 Client NewsCom
 Title Brochure
 Designer Susan Holton

5 **Design Firm** TXU Corp., Dallas TX
 Client Oncor
 Title 1st Look
 Art Directors Kass/Uehling

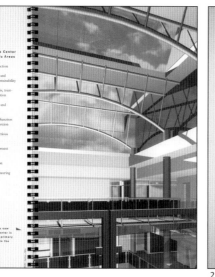

1

2

3

4

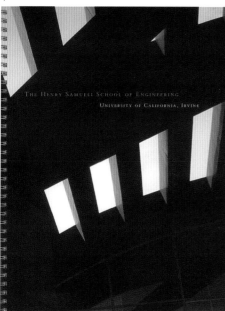

5

PROTECTING SMALL MOMENTS
and Big Commitments

CAMBRIDGE
SECURITY SYSTEMS

6

BROCHURES/COLLATERAL

1 **Design Firm** University of Missouri
Publications, Columbia MO
Client University of Missouri-Columbia
Title MU Life Science Center
Fundraising Package
Designer Blake Dinsdale

2 **Design Firm** Vince Rini Design,
Huntington Beach CA
Client Pace Lithographers
Title Capabilities Brochure
Art Director Vince Rini
Designer Vince Rini

3 **Design Firm** Vince Rini Design,
Huntington Beach CA
Client University of California, Irvine
Title The Henry Samueli School
of Engineering Brochure
Art Director Vince Rini
Designer Vince Rini
Photographer Stephen Swintek

4 **Design Firm** Walcoff Technologies,
Fairfax VA
Client Walcoff/DDL Omni
Title Environmental Services Brochure
Art Director David Hoff
Designer David Hoff

5 **Design Firm** Xerox Corporation,
Wilsonville OR
Title How Big Can You Dream
Sweepstakes
Art Director Ami Danielson
Designer Ami Danielson
Copywriter Halle Reese

6 **Design Firm** ZGraphics, Ltd.,
East Dundee IL
Client Cambridge Security Systems
Title Brochure Series
Art Director Joe Zeller
Designer Nate Baron

DIRECT MAIL/DIRECT RESPONSE

68

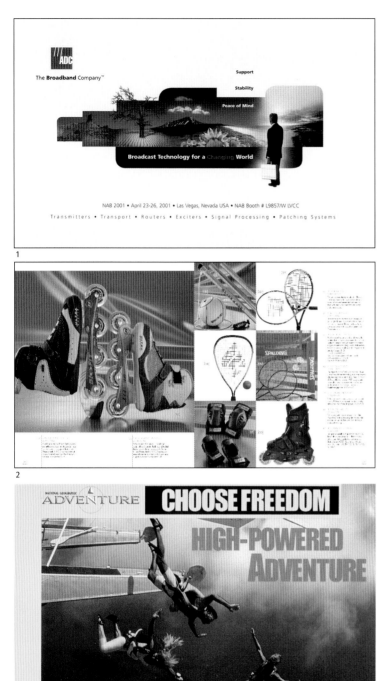

DIRECT MAIL/DIRECT RESPONSE

1 **Design Firm** ADC Creative Services Group, Eden Prairie MN
Client ADC
Title 2001 NAB Direct Mail Ad
Art Director Mark Sexton
Designer Mark Sexton
Photographer Bob Firth

2 **Design Firm** BI, Minneapolis MN
Title Awards Album
Art Director Debi Vecchione
Catalog Manager Vicki Heisler
Photographer Silver Lining

3 **Design Firm** Blue Sky Marcom, Inc., Springfield VA
Client National Geographic Society
Title Toughest Magazine On Earth
Art Director Robert Walter
Designer Robert Walter

4 **Design Firm** Brown & Company Design, Portsmouth NH
Client Fine Garden Art
Title Direct Mail
Art Director David Markovsky
Designers Matt Talbot, David Markovsky
Illustrator Jill Nooney
Photographer Jill Nooney

5 **Design Firm** Cisneros Design, Inc., Santa Fe NM
Client Golden Eye
Title Catalog
Art Director Yvette Jones
Designer Yvette Jones
Photographer Eric Swanson

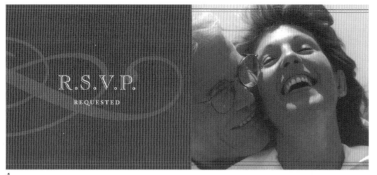

1

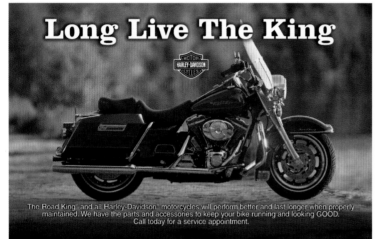

2

3

4

5

1

2

3

4

5

6

DIRECT MAIL/DIRECT RESPONSE

1 **Design Firm** Erbe Design, South Pasadena CA
 Client Chalk Hill Clematis
 Title Product Catalog
 Art Director Maureen Erbe
 Designers Maureen Erbe, Rita Sowins

2 **Design Firm** Faust Associates, Chicago IL
 Client University of Illinois at Urbana/Champaign
 Title MFA Art & Design Exhibition Catalog
 Art Director Bob Faust
 Designer Bob Faust
 Photographers Pro Graphics, Faust

3 **Design Firm** Harman Consumer Group, Woodbury NY
 Client JBL-Home
 Title JBL-Studio Series Specs
 Art Director Bob Abbatecola
 Designers Robin Witt, Chris Rugen
 Photographer Josh McClure

4 **Design Firm** JA Design Solutions, Coppell TX
 Client Van Childs - TXU Small Business Markets
 Title TXU Electric & Gas Average Billing Direct Mailer
 Art Director Jean Ashenfelter
 Designer Jean Ashenfelter

5 **Design Firm** JDG Communications, Inc., Falls Church VA
 Client Fairfax Symphony Orchestra
 Title Postcards
 Designers JDG Team
 Illustrator Bill Firestone

6 **Design Firm** JDG Communications, Inc., Falls Church VA
 Client Fairfax Symphony Orchestra
 Title 2002-03 Season Brochure
 Designers JDG Team
 Illustrator Bill Firestone

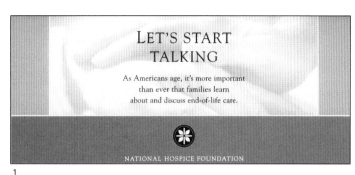

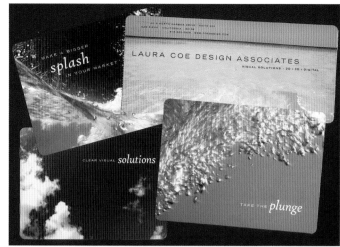

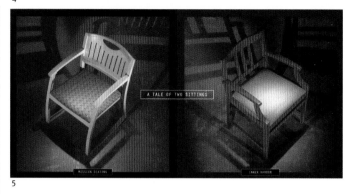

DIRECT MAIL/DIRECT RESPONSE

1 **Design Firm** Jeffrey Leder Inc., New York NY
 Client National Hospice Foundation
 Title Direct Mail
 Art Director Jeffrey Leder
 Designer Steven Albarracin

2 **Design Firm** Jensen Design Associates Inc., Long Beach CA
 Client Avery Dennison
 Title Avery Back to School Catalogue
 Art Director David Jensen
 Designers Elmer Jimenez, Alyssa Igawa, Stephanie Windham

3 **Design Firm** Kircher, Washington DC
 Client International Association of Amusement Parks and Attractions
 Title Postcard
 Creative Director Rich Gilroy
 Art Director Bruce E. Morgan
 Designer Tom Hight
 Illustrator John LaRosa
 Photographer Rick Brady

4 **Design Firm** Laura Coe Design Associates, San Diego CA
 Title Direct Mail Program
 Art Director Laura Coe Wright
 Designer Thomas Richman

5 **Design Firm** Lesniewicz Associates, Toledo OH
 Client Sauder Manufacturing
 Title Neocon Mailer
 Designer Jack Bollinger
 Photographer Jim Rohman

1

3

5

4

DIRECT MAIL/DIRECT RESPONSE

1 **Design Firm** Manugistics, Rockville MD
Title Envision Conference Program
Art Director Michael Frank
Designer Patrick Sesko

2 **Design Firm** Medallion Associates, New York NY
Client Barnes & Noble
Title 2001 Holiday Catalog
Art Director Becky Uberti
Designer Sherri Feldman

3 **Design Firm** Medallion Associates, New York NY
Client DKNY Company Stores
Title Holiday Direct Mail
Art Director Giselle Landers
Designer Judy Ma

4 **Design Firm** Michael Fanizza Designs, Haslett MI
Client The Catherine J. Smith Gallery-
Appalachian State University
Title The Fifteenth Rosen Exhibition
Art Director Michael Fanizza
Designer Michael Fanizza
Photographers Christopher Bledsoe, Michael Fanizza

5 **Design Firm** Paragraph, Philadelphia PA
Client Aramark
Title Paper Dolls Direct Mail
Art Director Bob Aretz
Designer Nicole Brouse

Stick with us!

Now there's a solution to protecting small sundry
items without distracting from the packaging.
Security solutions from Wallace. Exclusively
licensed to offer you Sensormatic Ultra•Max®
EAS labels that you simply peel and stick
to protect every product you sell.
When it comes to security, stick with the best.
USE WALLACE. WE'LL STICK WITH YOU.

1

Genealogy & Local History Online
—Now with Remote Access

Host a perpetual
**FAMILY REUNION
& HOME TOUR**
For families and homes across the
country IN YOUR LIBRARY

A full
year for
just $375

2

Turn the spotlight on your publication with ProQuest Archiver—
a turnkey, e-commerce-enabled online archive solution that lets
you highlight your publication's past, present, and future issues.

You decide

3

Safari Tech Books Online

4

Linking the World of Music

Musical America and MusicalAmerica.com

5

DIRECT MAIL/DIRECT RESPONSE

1 **Design Firm** Petertil Design Partners, Oak Park IL
 Client Wallace
 Title Direct Mail Series
 Art Director Kerry Petertil
 Designer Kathy Frey
 Illustrator Dan Frey

2 **Design Firm** ProQuest Information and Learning, Ann Arbor MI
 Client Digital Vault
 Title Genealogy & Local History Online Mailer
 Art Director Mark Howell
 Designer Mark Howell
 Writer Mary Kay Murray

3 **Design Firm** ProQuest Information and Learning, Ann Arbor MI
 Client ProQuest Archiver
 Title Mailer
 Art Director Mark Howell
 Designer Mark Howell
 Writer Kristin Ball

4 **Design Firm** ProQuest Information and Learning, Ann Arbor MI
 Client ProQuest
 Title Safari Direct Mail
 Art Director Mark Howell
 Designer Karen Nowosatko
 Writer Tina Creguer

5 **Design Firm** Rappy & Company, Inc., New York NY
 Client Musical America
 Title Promotional Brochure
 Art Directors Floyd Rappy, Robert Bertrand
 Designer Floyd Rappy
 Photographer Bill Milne

1

2

3

4

5

DIRECT MAIL/DIRECT RESPONSE

1 **Design Firm** River Graphics,
Lambertville NJ
Client Royal Worcester
Title The Chamberlain Collection
Designer Dona Griffin
Photographer Ricardo Barros

2 **Design Firm** Spielman Design, LLC,
Collinsville CT
Client Shaffer Smith Photography
Title Mailer Series
Designer Amanda Bedard
Illustrator Amanda Bedard
Photographers Jeff Shaffer, Dawn Smith

3 **Design Firm** Sullivan Creative,
Watertown MA
Client Arcstream
Title PDA Mailer
Art Director Wendy Wirsig
Designer Wendy Wirsig
Photographer Bill Horsman

4 **Design Firm** The Art Group Inc.,
Raleigh NC
Client Scott Health & Safety
Title TDC Mailer
Designer Matt Everley
Photographer Ilya Margolis

5 **Design Firm** Wolfgang Communications,
Inc., Irvine CA
Client Sparco USA
Title Tuning Catalog 3.0
Art Director Wolfgang Krogmann
Designer Wolfgang Krogmann

EDITORIAL DESIGN

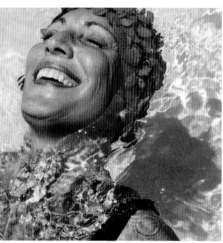

76

BOOKS
NEWSLETTERS
PUBLICATIONS

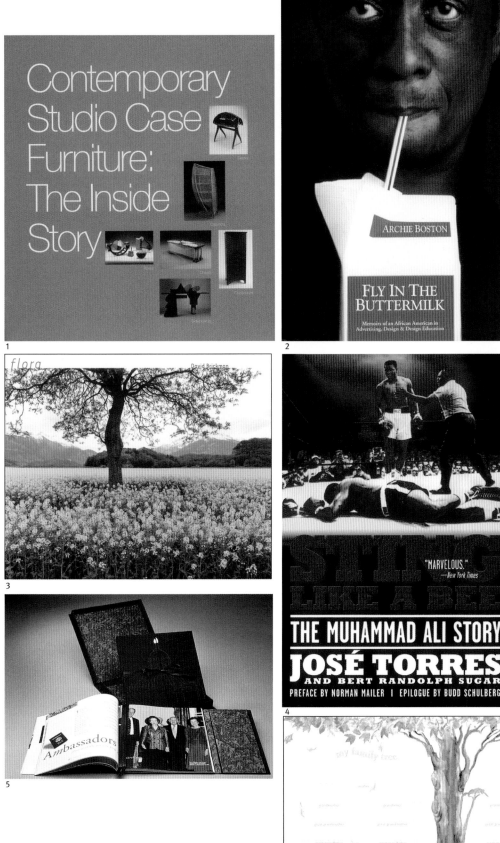

1 **Design Firm** Alcorn Publication
Design, Graeagle CA
Client Elvehjem Museum of Art
Title Contemporary Studio Case
Furniture: The Inside Story
Art Director David Alcorn
Designer David Alcorn

2 **Design Firm** Archie Boston
Graphic Design, Los Angeles CA
Title Fly in the Buttermilk
Art Director Archie Boston
Designer Archie Boston
Illustrators Thai Dao, Jay Joo,
Dave Mesfin
Photographer Todd Gray

3 **Design Firm** Aurora Design,
Niskayuna NY
Client David Brickman
Title Flora
Designer Jennifer Wilkerson
Photographer David Brickman

4 **Design Firm** Contemporary Books,
Chicago IL
Title Sting Like a Bee
Art Director Nick J. Panos
Designer Nick J. Panos
Photographer Hulton Deutsch

5 **Design Firm** Dever Designs, Laurel MD
Client Library of Congress/
Madison Council
Title Library of Congress Book
Art Director Jeffrey Dever
Designers Jeffrey Dever, Chris Ledford

6 **Design Firm** March of Dimes,
Mamaroneck NY
Title NICU Baby Book
Creative Director Kathy D'Aloise
Art Director Marsha Maurer
Designers Heather Castiglia,
Marsha Maurer
Illustrator Marsha Maurer

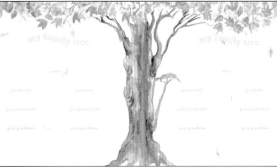

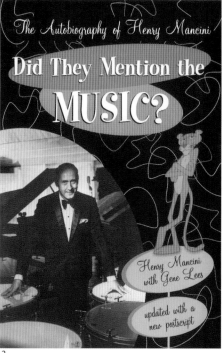

EDITORIAL DESIGN BOOKS

1 **Design Firm** Nassar Design, Brookline MA
Client Harvard Design School
Title Hong Kong: Defining the Edge
Art Director Nelida Nassar
Designer Margarita Encomienda

2 **Design Firm** Rowman & Littlefield Publishing Group, Lanham MD
Client Cooper Square Press
Title Did They Mention the Music?
Art Director Gisele Heny
Designer Jennifer Noel Huppert
Photographers Michael Ochos & MGM

3 **Design Firm** Rowman & Littlefield Publishing Group, Lanham MD
Client Rowman & Littlefield
Title Simone de Beauvoir's Philosophy of Lived Experience
Art Director Gisele Heny
Designer Kelly McDermett

4 **Design Firm** Wendell Minor Design, Washington CT
Client Harper Collins
Title Cliff Hanger
Art Director Al Cetta
Designer Wendell Minor
Illustrator Wendell Minor

5 **Design Firm** Wendell Minor Design, Washington CT
Client Putnam
Title Revenge of the Whale
Art Director Cecilia Yung
Designer Wendell Minor
Illustrator Wendell Minor

6 **Design Firm** Westat Graphic Arts Department, Rockville MD
Client U.S. Department of Agriculture
Title Food Model Booklet
Art Director Shayna Heller
Designer Tracey Summerall
Illustrator Tracey Summerall

1

2

3

4

5

6

EDITORIAL DESIGN NEWSLETTERS

1 **Design Firm** Faust Associates, Chicago IL
Client The Peninsula Hotel Chicago
Title Le Bon Viveur Newsletter
Art Director Bob Faust
Designer Michael Mesker
Illustrator Michael Mesker

2 **Design Firm** Franke and Fiorella,
Minneapolis, MN
Client 3M
Title Championship Newsletter
Art Director Craig Franke
Designer Richard Ketelsen
Photographer John Forsman

3 **Design Firm** Gecko Creative, Ellicott City MD
Client Spacenet
Title Connect Newsletter
Art Director Matt Rowland
Designer Matt Rowland

4 **Design Firm** JA Design Solutions, Coppell TX
Client Amber D'Amico - TXU
Title TXU View - Employee Newsletter
Art Director Jean Ashenfelter
Designer Jean Ashenfelter

5 **Design Firm** Jacqueline Barrett Design Inc.,
Oceanport NJ
Client Merck & Co., Inc.
Title Merck World - Special Report:
Merck People at Ground Zero
Art Director Jacqueline Barrett
Designer Jacqueline Barrett

6 **Design Firm** Jacqueline Barrett Design Inc.,
Oceanport NJ
Client Merck & Co., Inc.
Title Merck World - June 2001
Art Director Jacqueline Barrett
Designer Jacqueline Barrett

1

2

3

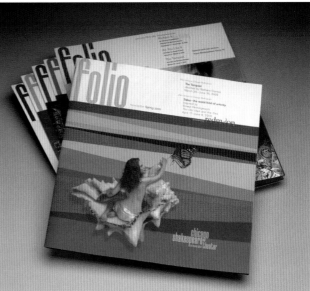

4

5

EDITORIAL DESIGN NEWSLETTERS

1 Design Firm kor group, Boston MA
Title Newsletter
Art Directors MB Jarosik, Karen Dendy
Designer Kjerstin Westgaard

2 Design Firm Latina Media Ventures, New York NY
Title Latina Quarter
Art Director Irasema Rivera
Designer Irasema Rivera

3 Design Firm Latina Media Ventures, New York NY
Title Focus
Art Director Irasema Rivera
Designer Irasema Rivera

4 Design Firm Studio/Lab Chicago, Chicago IL
Client Chicago Shakespeare Theater
Title Folio Spring 2002 Newsletter
Art Director Jill Hoffheimer
Designers Jill Hoffheimer, Kristin Gurnitz

5 Design Firm The Humane Society of the United States, Gaithersburg MD
Title Wild Neighbors News
Art Director Paula Jaworski
Designer Christine Edwards

1

4

2

3

5

EDITORIAL DESIGN PUBLICATIONS

1 **Design Firm** And Baby Magazine, Brooklyn NY
Title May/June 2002
Art Directors Kathleen Weiss, Alina Wilczynski
Designer Kathleen Weiss
Photographers Bradford Noble, John Russo

2 **Design Firm** Bloomberg, Princeton NJ
Client Bloomberg Wealth Manager Magazine
Title December 2001/January 2002
Art Director Laura Zavetz
Designers Laura Zavetz, Bea McDonald

3 **Design Firm** Bloomberg, Princeton NJ
Client Bloomberg Wealth Manager Magazine
Title When Doctors Pack It In
Art Director Laura Zavetz
Designer Laura Zavetz
Photographer Hugh Kretschmer

4 **Design Firm** Bloomberg, Princeton NJ
Client Bloomberg Wealth Manager Magazine
Title The Works
Art Director Laura Zavetz
Designer Laura Zavetz
Photographer Trevor Pearson

5 **Design Firm** Bloomberg, Princeton NJ
Client Bloomberg Wealth Manager Magazine
Title October 2001 Issue
Art Director Laura Zavetz
Designers Laura Zavetz, Bea McDonald

1

5

3

1

2

5

EDITORIAL DESIGN PUBLICATIONS

1 **Design Firm** Concept Foundry, Bethesda MD
 Client The George Washington University
 Title Common Ground
 Art Director Jim Gray
 Designer Jim Gray

2 **Design Firm** Custom Publishing Group,
 Cleveland OH
 Client The Leading Edge Alliance
 Title Publication Cover
 Art Director Amanda Horvath
 Designer Amanda Horvath
 Illustrator Brian Willse

3 **Design Firm** Dever Designs, Laurel MD
 Client Liberty Magazine
 Title Lead Us Not Into Temptation
 Art Director Jeffrey Dever
 Designer Jeffrey Dever
 Illustrator Ralph Butler

4 **Design Firm** Dever Designs, Laurel MD
 Client Liberty Magazine
 Title The Revolution of 1800
 Art Director Jeffrey Dever
 Designer Amy White Sucherman
 Illustrator Sally Wern Comport

5 **Design Firm** Gill Fishman Associates,
 Cambridge MA
 Client Deloitte & Touche-Growth Company Service
 Title Trajectory-Winter 2002
 Art Director Gill Fishman
 Designer Tammy Torrey

1

2

3

4

5

1

3

2

5

EDITORIAL DESIGN PUBLICATIONS

1 **Design Firm** Old Bergen Design, Jersey City NJ
 Client Hadassah
 Title February 2002 Issue
 Art Director Kenneth Quail
 Designer Kenneth Quail

2 **Design Firm** Old Bergen Design, Jersey City NJ
 Client Hadassah
 Title January 2002 Issue
 Art Director Kenneth Quail
 Designer Kenneth Quail

3 **Design Firm** O'Neil Communications, Tyngsboro MA
 Client Compaq
 Title Inform
 Art Director Mikaela Pentedemos
 Designers Leslie Bunnell, Gretchen Bond-Quinn, Kori Kennedy

4 **Design Firm** Pearson Education Development Group, New York NY
 Client Prentice Hall
 Title Literature
 Art Director William McAllister
 Designer Yin Ling Wong
 Fine Art Gustave Caillebote

5 **Design Firm** Popular Mechanics, New York NY
 Title Sonic Cruiser, October 2001
 Art Director Bryan Canniff
 Designer Bryan Canniff

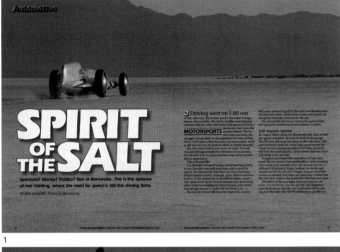

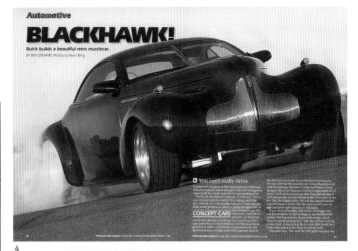

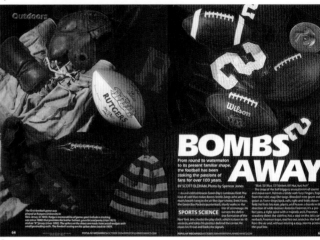

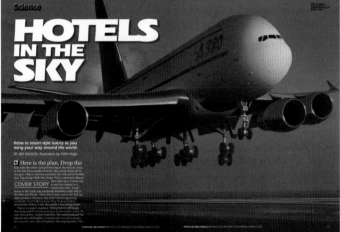

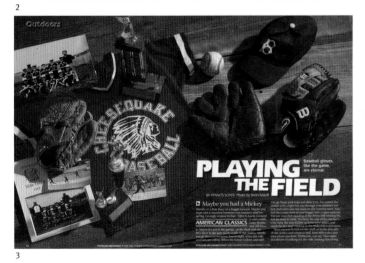

EDITORIAL DESIGN PUBLICATIONS

1 **Design Firm** Popular Mechanics, New York NY
Title Spirit of the Salt, January 2001
Art Director Bryan Canniff
Designer Harriette Lawler
Photographer Bill Delaney

2 **Design Firm** Popular Mechanics, New York NY
Title Hotels in the Sky, March 2001
Art Director Bryan Canniff
Designer Bryan Canniff
Illustrator Attila Hejja

3 **Design Firm** Popular Mechanics, New York NY
Title Playing the Field, May 2001
Art Director Bryan Canniff
Designer Bryan Canniff
Photographer Brian Kosoff

4 **Design Firm** Popular Mechanics, New York NY
Title Blackhawk, June 2001
Art Director Bryan Canniff
Designer Harriette Lawler
Photographer Kevin Wing

5 **Design Firm** Popular Mechanics, New York NY
Title Bombs Away, September 2001
Art Director Bryan Canniff
Designer Bryan Canniff
Photographer Spencer Jones

1

2

3

4

5

EDITORIAL DESIGN PUBLICATIONS

1 **Design Firm** Prentice Hall, Higher Education,
Upper Saddle River NJ
Title The Prentice Hall Anthology of
Latino Literature
Art Director Robert Farrar-Wagner
Designer Robert Farrar-Wagner
Illustrator Jose Ortega

2 **Design Firm** Semiconductor Magazine,
San Jose CA
Title Finding the Path to ebusiness
Art Director Michael Hilker
Designer Michael Hilker
Illustrator Michael Hilker
Photographer Rick Der

3 **Design Firm** Semiconductor Magazine,
San Jose CA
Title Venture Capital
Art Director Michael Hilker
Designer Michael Hilker
Illustrator Craig Frazier

4 **Design Firm** Stamats Communications,
Cedar Rapids IA
Title Buildings, May 2001
Art Director Elisa Geneser
Designers Elisa Geneser, Scott Easton

5 **Design Firm** Towson University, Towson MD
Client Undergraduate Marketing
Title 2001-2002 Portfolio and Application
Art Director Kathy Malanowski
Designer Kathy Malanowski
Photographer Kanji Takeno

1

2

3

4

5

6

EDITORIAL DESIGN PUBLICATIONS

1 **Design Firm** USA Weekend, McLean VA
Title Robert Redford
Creative Manager Casey Shaw
Art Director Pamela Smith
Design Director Leon Lawrence III
Photographer Art Streiber

2 **Design Firm** USA Weekend, McLean VA
Title Finding Foster
Creative Manager Casey Shaw
Design Director Leon Lawrence III
Photographer E.J. Camp

3 **Design Firm** USA Weekend, McLean VA
Title How Well Do You Know Harry Potter?
Creative Manager Casey Shaw
Design Director Leon Lawrence III
Photographer Warner Bros.

4 **Design Firm** USA Weekend, McLean VA
Title Cal: End of the Iron Age
Creative Manager Casey Shaw
Design Director Leon Lawrence III
Photographer Brad Trent

5 **Design Firm** USA Weekend, McLean VA
Title Thanksgiving
Creative Manager Casey Shaw
Art Director Pamela Smith

6 **Design Firm** York Graphic Communication,
Rockville Centre NY
Client St. Vincent's Services
Title Spanning Three Centuries of Caring
Designer Robert Y. Williamson
Photographer Richard Frank

ENVIRONMENTAL DESIGN

90

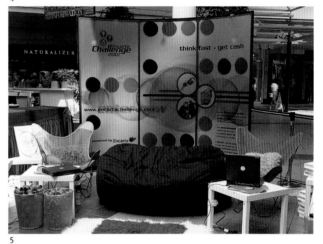

ENVIRONMENTAL DESIGN

1 **Design Firm** Alterpop, San Francisco CA
Client St. Paul's Towers
Title Environmental Signage
Art Director Doug Akagi
Designer Kimberly Powell

2 **Design Firm** Crawford/Mikus Design, Inc., Atlanta GA
Client AWI
Title Tradebooth
Art Director Elizabeth Crawford
Designer Michelle May

3 **Design Firm** Design360 Inc., New York NY
Client Reuters America, Inc.
Title Reuters/Instanet Lobby Monitors
Art Director Don Kiel
Designer Alicia Inman
Photographer Elizabeth Felicella

4 **Design Firm** Design360 Inc., New York NY
Client Stargazer Foundation
Title Stargazer Lobby Signage
Art Director Don Kiel
Designer Enrique Von Rohr
Photographer Michael Matsil

5 **Design Firm** Edelman Design Worldwide, Chicago IL
Client Microsoft Encarta
Title Encarta Logo & Exhibit
Art Director Teresa Costantini
Designer Josh Witherspoon

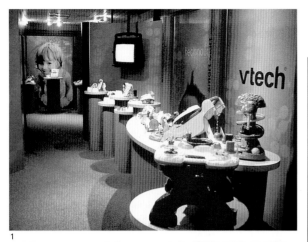

1

2

3

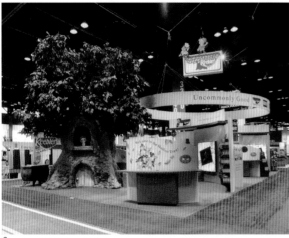

5

4

6

1 **Design Firm** Edelman Design Worldwide, Chicago IL
Client vtech
Title Exhibit
Art Director Teresa Costantini
Designer Josh Witherspoon

2 **Design Firm** Hunt Design Associates, Pasadena CA
Client Clear Channel/Wyatt Design Group
Title Chicano Now! American Expressions
Art Director Jennifer Bressler
Designers Jennifer Bressler, Heather Watso
Illustrators Richard Duardo, Culture Clash
Photographer Hunt Design Associates

3 **Design Firm** Launch Creative Marketing, Hillside IL
Client Keebler Company
Title Welcome to the Hollow Tree- Trade Show Display
Art Director Bill Meier
Designer Pat Indolak

4 **Design Firm** Square Peg Design, Emeryville CA
Client Yahoo!
Title Corporate Campus
Art Director Scott Cuyler
Designer Scott Cuyler

5 **Design Firm** Wallach Glass Studio, Santa Rosa CA
Client Baylor College of Medicine
Title Donor Lobby Art Glass
Art Director Christina Wallach
Designers Christina Wallach, Supreeya Pongkasem, Eric Zammett
Illustrators Tenaya Wallach, Lois Greenfield

6 **Design Firm** Yamamoto Moss, Minneapolis MN
Client Fraser
Title Wall Graphics
Art Director Joan Frenz
Designer Hiroshi Watanabe
Illustrator Hiroshi Watanabe

IDENTITY DESIGN

93

CORPORATE IDENTITY PROGRAMS

LETTERHEAD/STATIONERY

LOGOS

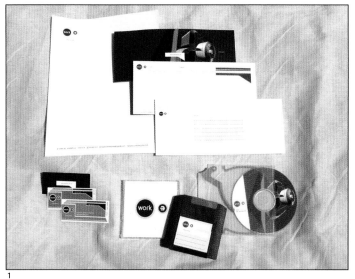

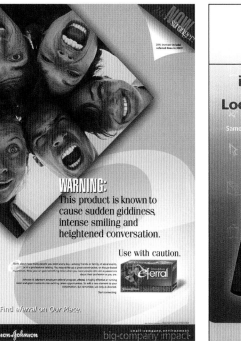

ARCHIPELAGO

IDENTITY DESIGN
CORPORATE IDENTITY PROGRAMS

1 **Design Firm** (WORK), Elizabeth NJ
 Title Stationery
 Art Directors Alex Medina, Cesar Rubin

2 **Design Firm** Addis, Berkeley CA
 Client Archipelago
 Title Identity
 Art Director Bob Hullinger
 Designer Suzanne Hadden

3 **Design Firm** Baldwin & Obenauf, Inc., Raritan NJ
 Client Johnson & Johnson Recruiting
 Title eferral Employee Referral Program
 Art Director George Jackus
 Designers George Jackus, Rob Adams, Dan Schmolen
 Photographer Allan Shoemake

4 **Design Firm** Baldwin & Obenauf, Inc., Raritan NJ
 Client Johnson & Johnson Strategic Sourcing
 Title Johnson & Johnson estore
 Art Director Ron Badum
 Designer Ron Badum
 Illustrator Ron Badum

5 **Design Firm** Cardinal Design, Naperville IL
 Client Yoga Energy
 Title Corporate Identity
 Art Director Kathleen Johnson
 Designer Kathleen Johnson
 Illustrator Kathleen Johnson

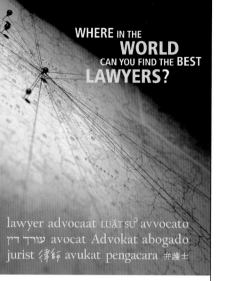

Great Taste Without Compromise™

5

IDENTITY DESIGN
CORPORATE IDENTITY PROGRAMS

1 **Design Firm** Curtis Marketing Group, St. Joseph MN
 Client Sameer Puri, DDS
 Title Corporate Image
 Art Director Jason Puffe
 Designer Bret Wieseler
 Illustrator Matt Lurken-Turdik
 Photographer Stewart Lorenz

2 **Design Firm** Devious Design, Moss Beach CA
 Client High Tides Magazine
 Title Promotion
 Art Director Kenneth Davis
 Designer Kenneth Davis
 Illustrator Kenneth Davis

3 **Design Firm** DNO Productions Inc., San Francisco CA
 Client ChemConnect
 Title Identity
 Designer Keith Hart

4 **Design Firm** Emily Rich Design, Encino CA
 Client Interlaw
 Title Media Kit
 Art Director Emily Rich
 Designer Emily Rich

5 **Design Firm** Gauger & Santy, San Francisco CA
 Client Barbara's Bakery
 Title Identity
 Designer Lori Murphy

1

2

3

4

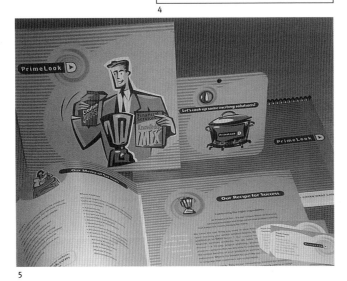

5

IDENTITY DESIGN
CORPORATE IDENTITY PROGRAMS

1 **Design Firm** Ian Perkins Design, Norfolk UK
Client Anita Giraldo
Title Identity
Art Director Ian Perkins
Designers Ian Perkins, Matt Gill
Illustrator Ian Perkins
Photographer Anita Giraldo

2 **Design Firm** Ian Perkins Design, Norfolk UK
Client Roundhouse Architecture
Title Identity
Art Director Ian Perkins
Designer Ian Perkins

3 **Design Firm** Integrity Graphic Design,
New Hartford NY
Client Central New York Independent
Practice Association
Title Logo
Art Director Linda A. Zielinski
Designer Linda A. Zielinski
Illustrator Linda A. Zielinski

4 **Design Firm** Murphy Design, Philadelphia PA
Client ARAMARK Corporation
Title FSS500 Race Report
Art Director Rosemary Murphy
Designers Rosemary Murphy, Jennifer Detwiler,
Kristina McFadden

5 **Design Firm** PrimeLook, Inc., New York NY
Title Branding
Art Director Frank Frehill
Designers Michelle DiCicco, Cynthia Neides

1

4

2

5

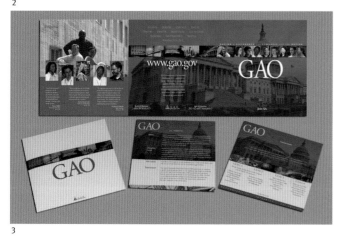

3

IDENTITY DESIGN
CORPORATE IDENTITY PROGRAMS

1 **Design Firm** Serendipity Communications, Christiansburg VA
 Client Roanoke County Economic Development
 Title Folder
 Art Director Christina Motley
 Designer Jennifer Yax

2 **Design Firm** The Sloan Group, New York NY
 Title Promo Kit
 Art Director Rita Arifin
 Copywriter Don Kilcoyne

3 **Design Firm** U.S. General Accounting Office, Washington DC
 Client Human Resources Office
 Title GAO Recruitment Brochure
 Art Director Theresa Mechem
 Designer Theresa Mechem
 Photographer Richard Rockburn

4 **Design Firm** UP Design, Montclair NJ
 Title Identity Material
 Art Director Gary Underhill
 Designer Wendy Peters

5 **Design Firm** US Bancorp Asset Management, Minneapolis MN
 Client First American Funds
 Title Corporate Identity
 Art Director Jim Madson
 Designers Todd Nesser, Jo Davidson
 Illustrator Mark Summers

1

4

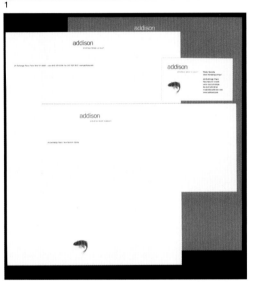

2

3

IDENTITY DESIGN
LETTERHEAD/STATIONERY

1 **Design Firm** Adam, Filippo & Associates, Pittsburgh PA
Client Promistar Financial
Title Stationery Package
Art Director Robert Adam
Designer Martin Perez

2 **Design Firm** Addison, New York NY
Title Stationery
Art Director Brian Collentine
Designer Robin Awes

3 **Design Firm** Banjocreative, New York NY
Client MicroSquad
Title Stationery
Designer James Kuhnert

4 **Design Firm** Carol McLeod Design, Mashpee MA
Client BendTek
Title Stationery
Art Director Carol McLeod
Designer Chris Daigneault

5 **Design Firm** Cisneros Design, Inc., Santa Fe NM
Client PD Bean Coffeehouse
Title Stationery
Art Director Brian Hurshman
Designer Brian Hurshman
Illustrator William Rotsaert

5

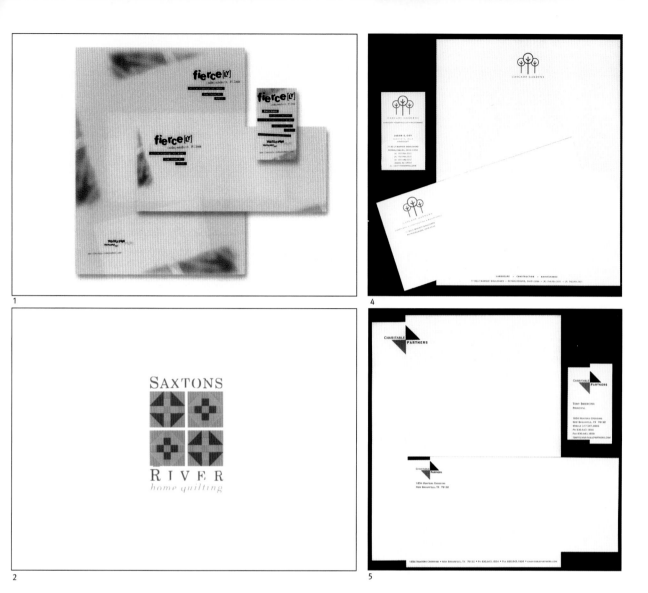

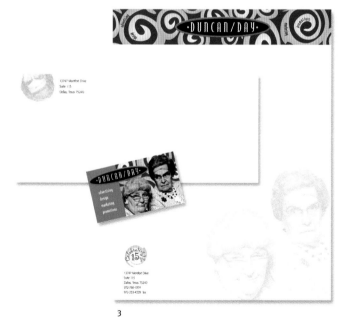

1 **Design Firm** Creative Dynamics, Inc., Las Vegas NV
 Client Fiercely Independent Films
 Title Letterhead
 Art Director Victor Rodriguez
 Designer Mackenzie Walsh

2 **Design Firm** Dakota Group, Inc., Wilton CT
 Client Saxtons River
 Title Stationery
 Art Director Susan Bruneau
 Designer Laura Offenberg Dague

3 **Design Firm** Duncan/Day Advertising, Dallas TX
 Title Letterhead
 Art Director Stacey Day
 Designer Stacey Day

4 **Design Firm** Epstein Design Partners, Inc., Cleveland OH
 Client Cascade Gardens
 Title Stationery
 Designer Jileen Coy

5 **Design Firm** Franklin Design Group, Addison TX
 Client Charitable Partners
 Title Stationery
 Art Director Wendy Hanson
 Designer Wendy Hanson

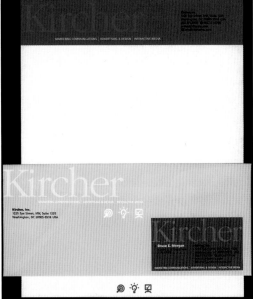

1

2

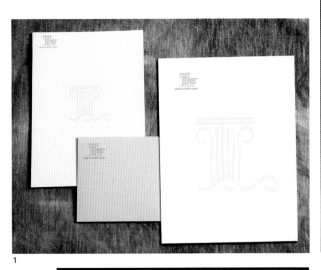

3

4

5

IDENTITY DESIGN
LETTERHEAD/STATIONERY

1 **Design Firm** Janet Hughes and Associates, Wilmington DE
Client DuPont Pharmaceuticals Company
Title Leadership Council Letterhead
Art Director Peter Stolvoort
Designer Peter Stolvoort
Illustrator Carol Stolvoort

2 **Design Firm** JDC Design, Inc., New York NY
Client SILK - New York World Class Cabaret
Title Stationery
Art Director Jeff Conway
Designer Valentina Kogan

3 **Design Firm** Kircher, Washington DC
Title Stationery
Art Director Bruce E. Morgan
Designer Bruce E. Morgan

4 **Design Firm** Leibowitz Communications, New York NY
Client Commotion Promotions
Title Stationery System
Art Director Paul Leibowitz
Designer Rick Bargmann

5 **Design Firm** Nassar Design, Brookline MA
Title Stationery
Art Director Nelida Nassar
Designer Nelida Nassar
Illustrator Nelida Nassar
Photographer Nelida Nassar

4

1

5

2

3

IDENTITY DESIGN
LETTERHEAD/STATIONERY

1 **Design Firm** Nassar Design, Brookline MA
Client Elizabeth Gibb Architect
Title Stationery
Art Director Nelida Nassar
Designer Margarita Encomienda

2 **Design Firm** Nassar Design, Brookline MA
Client Jeffry Pond Architect Inc.
Title Stationery
Art Director Nelida Nassar
Designer Margarita Encomienda

3 **Design Firm** Natalie Kitamura Design, San Francisco CA
Title Identity System
Art Director Natalie Kitamura
Designers Lisa Winter, Elizabeth Fee

4 **Design Firm** Noon, San Francisco CA
Title Stationery
Art Director Cinthia Wen
Designers Cinthia Wen, Tomonari Ito

5 **Design Firm** Norasack Design, Alexandria VA
Title Stationery
Designer Norasack Pathammavong

IDENTITY DESIGN
LETTERHEAD/STATIONERY

1 **Design Firm** North Castle Design,
Stamford CT
Title Stationery
Art Director Rudy Mossa
Designer John Ferris

2 **Design Firm** North Castle Design,
Stamford CT
Client Xeflex Software
Title Stationery
Designer John Ferris

3 **Design Firm** Open Eye Design, Inc.,
Fullerton CA
Title Stationery
Art Director Greg Herrington
Designer Greg Herrington

4 **Design Firm** PaperMouse, Maple Grove MN
Client Great Cakes Management, Inc.
Title Orono Woods Stationery
Art Director Shelly Hokel
Designer Shelly Hokel

5 **Design Firm** Patricia Vogt Graphic Design,
Chicago IL
Title Identity
Art Director Patricia Vogt
Designer Patricia Vogt

6 **Design Firm** Pennyhorse Advertising,
Merrimack NH
Client Aesthetics @131 Main
Title Letterhead & Stationery
Art Director Michael Anderson
Designer Jennifer Cockerham

1

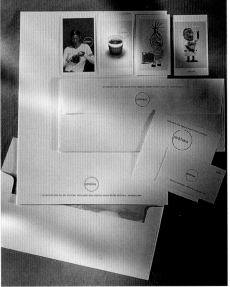

2

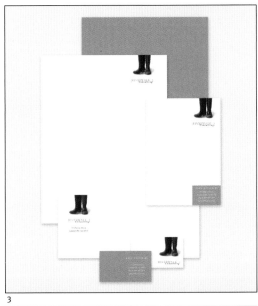

3

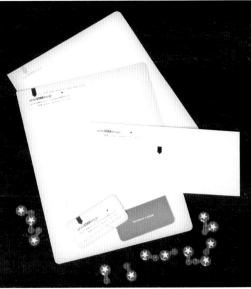

4

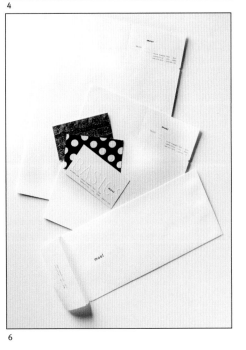

5

6

1 **Design Firm** Pennyhorse Advertising,
Merrimack NH
Client The Zoo
Title Stationery
Art Director Michael Anderson
Designer Jennifer Cockerham

2 **Design Firm** Pinkhaus, Miami FL
Title Stationery/Package
Art Director Joel Fuller
Designer Todd Houser
Illustrator John Westmark
Production Manager Suzanne Bernstein
Copywriter Shelly Shiner
Photographer Michael Dakota

3 **Design Firm** River Graphics,
Lambertville NJ
Client Riverwalk Consulting
Title Letterhead/Logo
Designer Dona Griffin

4 **Design Firm** The Humane Society of the
United States, Gaithersburg MD
Title Humane Legacy
Art Director Paula Jaworski
Designer Paula Jaworski

5 **Design Firm** whiteSTARdesign,
Bethlehem PA
Title Letterhead
Art Director Peter Stolvoort
Designers Peter Stolvoort, Wojciech
Goleniewski

6 **Design Firm** Williams and House,
Avon CT
Client Moo
Title Identity
Art Director Pam Williams
Designer Rich Hollant, CO:LAB
Copywriter Pam Williams

1

PROMISTAR

2

AI&E
Advertising Images & Embroidery, Inc.

3

P.S. 321

Una Familia

One Family

4

Maddi's
GALLERY

5

6

Owsley Advisors, Inc.
a wise choice in Financial Services

7

CasaleDesign

8

1 **Design Firm** Academy of Art College,
San Francisco CA
Client Bay Area Rapid Transit (BART)
Title Logo
Art Director Brian Lovell
Designer Esther Hong
Illustrator Esther Hong

2 **Design Firm** Adam, Filippo & Associates,
Pittsburgh PA
Client Promistar Financial
Title Logo
Art Director Robert Adam
Designer Martin Perez

3 **Design Firm** Advertising Images &
Embroidery, Inc., Richmond VA
Title Logo
Designers Al & Marsha Dietz

4 **Design Firm** arnagraphics, Brooklyn NY
Client Public School 321, Park Slope
Title One Family
Designer Lisa di Liberto
Illustrator Lisa di Liberto

5 **Design Firm** Benson & Hepker Design,
Iowa City IA
Client Maddi's Gallery
Title Logo
Art Director Joan Benson
Designer Robyn Hepker

6 **Design Firm** Bright Water Design, Inc.,
Streamwood IL
Client Mike Walker - Musician
Title Logo/ Identity
Art Director Jennifer O'Claire
Designer Jennifer O'Claire

7 **Design Firm** Carla Mattioli Design &
Production, Bel Air MD
Client Owsley Advisors, Inc.
Title Logo
Art Director Carla Mattioli
Designer Carla Mattioli

8 **Design Firm** Casale Design, Inc.,
New York NY
Client Casale Design, Inc.
Title Casale Design Corporate Identity
Designer George T. Casale

Dust Buster Cordless Vac®

1

New Mexico State Parks

2

ca smart

3

JOBPRO

4

dotcommons.com

5a

5b

Mayor Jane's Golf Outing
— 2002 —

6

anagen
therapeutics

7

musicWorx™

8

IDENTITY DESIGN
LOGOS AND TRADEMARKS

1 **Design Firm** Catalpha Advertising & Design,
Towson MD
Client Black and Decker
Title Dust Buster Logo
Art Director Karen Kerski
Designer Kolleen Kilduff

2 **Design Firm** Cisneros Design, Inc.,
Santa Fe NM
Client New Mexico State Parks
Title Logo
Art Directors Eric Griego, Brian Hurshman
Designer Amy Anderson
Illustrators Amy Anderson, Eric Griego

3 **Design Firm** Computer Associates
International, Inc., Islandia NY
Title CA Smart Ingredient Branding Logo
Designer Loren Moss Meyer

4 **Design Firm** Creative Fusion Design
Company, Branford CT
Client JobPro Staffing Services
Title Logo
Art Director Craig Des Roberts
Designer Craig Des Roberts

5 **Design Firm** Design360 Inc., New York NY
Client Stargazer Foundation
Title Stargazer Logos
Art Director Enrique Von Rohr

6 **Design Firm** Division Street Design,
Westlake OH
Client The Mayor of Cleveland
Title Mayor Jane's Golf Outing Logo
Art Director Chris Clotz
Designer Chris Clotz

7 **Design Firm** Edelman Design Worldwide,
Chicago IL
Client Anagen Therapeutics
Title Logo
Art Director John Avila
Designer Joe Ondrla

8 **Design Firm** Equilateral Design,
San Diego CA
Client MusicWorx of California
Title Identity
Art Director Colleen Carr
Designer Colleen Carr

1

2

bulk_gourmet_

3

4

PRODUCTION SYSTEMS

On the Road to

SUCCESS

5

itQ

6

alimente.com®

The **e-market** for supermarkets℠

7

DIGITALCROWD

8

IDENTITY DESIGN
LOGOS AND TRADEMARKS

1 **Design Firm** Ezect, Inc., Kenilworth NJ
Title Logo
Art Director Pamela Wood
Designer Pamela Wood

2 **Design Firm** Fathom Creative,
Washington DC
Client Iris Alliance Fund
Title Logo
Designer Dan Banks

3 **Design Firm** Faust Associates,
Chicago IL
Client The Bulk Gourmet
Title Logo
Art Director Bob Faust
Designer Bob Faust

4 **Design Firm** Finished Art Inc.,
Atlanta GA
Client La Tofferie
Title Logo
Art Directors Donna Johnston,
Kannex Fung
Designer Kannex Fung

5 **Design Firm** Foth & Van Dyke,
Green Bay, WI
Client Foth & Van Dyke-
Production Systems SBU
Title On the Road to Success Logo
Art Director Daniel Green
Designer Daniel Green

6 **Design Firm** Franke and Fiorella,
Minneapolis, MN
Client General Mills
Title ITQ Logo
Designer Craig Franke

7 **Design Firm** GraphicVision Design
Studios, Ft. Lauderdale FL
Client Alimente.com
Title Logo
Art Director Elsy Aumann
Designer David Utrera

8 **Design Firm** Indicia Design, Inc.,
Kansas City MO
Client Digital Crowd, Inc.
Title Logo
Art Director Ryan Hembree
Designer Ryan Hembree

1

5

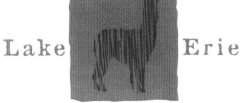

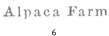

2

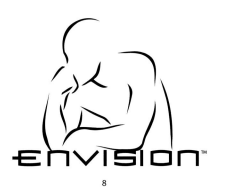

6

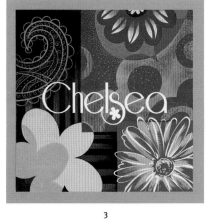

7

3

4

IDENTITY DESIGN
LOGOS AND TRADEMARKS

1 **Design Firm** Indicia Design, Inc.,
Kansas City MO
Client MedPlans Partners
Title Logo
Art Directors Ryan Hembree,
Clark Bystrom
Designers Ryan Hembree,
Clark Bystrom

2 **Design Firm** Julie Chun Design,
Mill Valley CA
Client Boyle Park Tennis
Title Boyle Park Tennis Logo
Designer Julie L. Chun
Illustrator Julie L. Chun

3 **Design Firm** Kaleidoscope Design,
Snohomish WA
Client Seco Development Inc.
Title Chelsea Identity
Art Director Cynthia Lynn
Designer Cynthia Lynn
Illustrator Robert Williamson

4 **Design Firm** Kircher, Washington DC
Client Biotechnology Industry
Organization
Title Biojurist.org Logo
Art Director Bruce E. Morgan
Designer Bruce E. Morgan

5 **Design Firm** Kircher, Washington DC
Client Interlocking Media
Title Logo
Art Director Bruce E. Morgan
Designer Bruce E. Morgan

6 **Design Firm** Lesniewicz Associates,
Toledo OH
Client Lake Erie Alpaca Farm
Title Logo
Art Director Terry Lesniewicz
Designer Amy Lesniewicz

7 **Design Firm** Lesniewicz Associates,
Toledo OH
Client Racing for Recovery
Title Logo
Designer Amy Lesniewicz

8 **Design Firm** Lewis Design Group,
Greensboro NC
Client Envision
Title Logo
Art Directors Todd Lewis,
Rod Smitherman
Designer Rod Smitherman
Illustrator David Stanley

Globa Fluency

1

2

ONE**BOOK**AZ

3

ENVISION
2002

4

5

SUN VALLEY™

6

ARTEMIS

7

GUTHRIE

8

Simply Elegant

1

2

3

POETRY FESTIVAL
Orange County

4

PRO DANCE
Twin Cities

5

shine-on
translucent temporary haircolor

6

catalyst

7

Temple Beth Hillel-Beth El

צדקה

TZEDAKAH-THON
April 28, 2002 NISAN/IYAR 5762

8

1

2

3

SmartGown™

4

Teacher's Software Company

5

6

Donors Capital Fund

7

liberty
learning
center
click on life.

8

IDENTITY DESIGN
LOGOS AND TRADEMARKS

1 **Design Firm** Source/Inc., Chicago IL
 Client Valeo, Inc.
 Title Logo
 Art Director Bernie Dolph
 Designer Andrew Sechin
 Photographer John Welzenbach

2 **Design Firm** Stephen Longo &
 Associates, West Orange NJ
 Client Matsuya Japanese Steak House
 Title Logo
 Art Director Stephen Longo
 Designer Stephen Longo
 Illustrator Stephen Longo

3 **Design Firm** Studio/Lab Chicago,
 Chicago IL
 Client Whirlpool Corp.
 Title Duet Logo
 Art Director Marcia Lausen
 Designers Marcia Lausen,
 Louise Fennel

4 **Design Firm** StudioNorth,
 North Chicago IL
 Client Allegiance Healthcare
 Corporation
 Title SmartGown Logo
 Art Director Laura Campbell
 Designer Laura Campbell

5 **Design Firm** Teacher's Video Company,
 Tempe AZ
 Title Teacher's Software
 Company Logo
 Art Director Stephan R. Macior
 Designer Olga Zorkin

6 **Design Firm** The Art Group Inc.,
 Raleigh NC
 Client Only Here for the Milk
 Title Logo
 Art Director Shane Poteete
 Designer Shane Poteete
 Illustrator Shane Poteete

7 **Design Firm** The Leonard Resource
 Group, Inc., Alexandria VA
 Client Donors Capital Fund
 Title Logo
 Art Director Alex Dale
 Designer Alex Dale
 Illustrator Alex Dale

8 **Design Firm** Upright Communications,
 Cincinnati OH
 Client Liberty Learning Center
 Title Logo
 Art Director Beth Kaiser
 Designer Beth Kaiser

1

5

2

6

3

7

4

8

9

1 **Design Firm** Vanguard Communications,
Washington DC
Client FoodRoutes Network
Title foodroutes.org logo
Art Director Ryan LaLonde
Designer Kathy Keller
Illustrator Kathy Keller

2 **Design Firm** what!design, Allston MA
Client Songwriter Records
Title Logo
Art Director Damon Meibers
Designer Derek Aylward
Illustrator Derek Aylward

3 **Design Firm** what!design, Allston MA
Client Torque Consulting LLC
Title Logo
Art Director Damon Meibers
Designer Antonio Canobbio

4 **Design Firm** what!design, Allston MA
Client Vision Scope Inc.
Title Logo
Art Director Damon Meibers
Designer Damon Meibers

5 **Design Firm** World Savings Bank,
Oakland CA
Client Atlas
Title Atlas the Titan
Art Director John Wardlaw IV
Designer John Wardlaw IV

6 **Design Firm** Z Design, Olney MD
Client Bette G. Demarest, CPA
Title Logo
Art Director Irene Zevgolis
Designer Irene Zevgolis

7 **Design Firm** Z Design, Olney MD
Client Phase 3 Consulting
Title Logo
Art Director Irene Zevgolis
Designer Irene Zevgolis

8 **Design Firm** Z Eleven Design,
Apex NC
Client Smokey Mountain Hillbilly
Kettle Korn
Title Logo
Art Director Shane Poteete
Designer Shane Poteete
Illustrator Shane Poteete

9 **Design Firm** ZGraphics, Ltd.,
East Dundee IL
Client The Spice Merchant & Tea Room
Title Logo
Art Director LouAnn Zeller
Designer Kris Martinez Farrell

INTERNET DESIGN

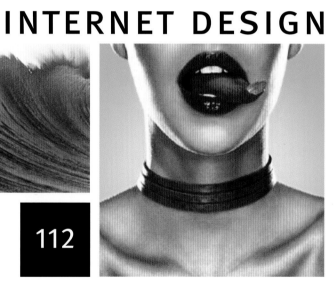

112

1

2

3

4

5

INTERNET DESIGN

1 **Design Firm** Addis, Berkeley CA
Client Pottery Barn Kids
Title Web Site
Art Director Deborah Smith Read
Designers Lisa Gaines, Joe Chang, Eileen Kendle

2 **Design Firm** Addison, New York NY
Client The McGraw-Hill Companies
Title Online Annual Report
Art Director David Kohler
Designer Scott Galbraith
Photographer Erika Larson

3 **Design Firm** Alterpop, San Francisco CA
Title Promotional Web Site
Art Director Doug Akagi

4 **Design Firm** BBK Studio, Inc., Grand Rapids MI
Client HermanMiller
Title Ethospace Site 2002
Art Director Kevin Budelmann
Designer Alison Popp
Photographer Herman Miller Archives

5 **Design Firm** Capital Associated Industries, Raleigh NC
Client Cranfill, Sumner & Hartzog, LLP
Title Web Site
Art Director Beth Greene
Designer Beth Greene

1

4

2

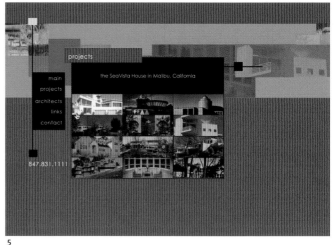

5

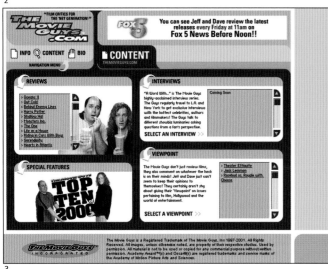

3

INTERNET DESIGN

1 **Design Firm** Casale Design, Inc., New York NY
Client ITC Travel & Tours
Title Hatiyul Web Site
Designer George T. Casale
Copywriter Guy Millo

2 **Design Firm** Cisneros Design, Inc., Santa Fe NM
Title Web Site
Art Director Fred Cisneros
Designers Janine Pearson, Yvette Jones
Photographers Chris Corrie, Eric Swanson

3 **Design Firm** Creative Dynamics, Inc., Las Vegas NV
Client The Movie Guys
Title Web Site
Art Director Casey Corcoran
Designer Casey Corcoran

4 **Design Firm** Creative Fusion Design Company, Branford CT
Client JobPro Staffing Services
Title Web Site
Art Director Chris Walsh
Designer Chris Walsh

5 **Design Firm** Design Moves, Ltd., Highland Park IL
Client Moses Architecture
Title Web Site
Art Director Laurie Medeiros Freed
Designer William R. Sprowl
Illustrator William R. Sprowl

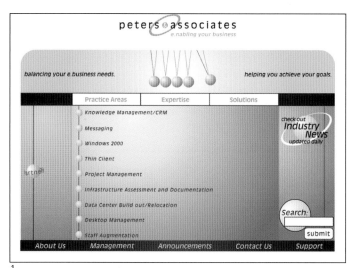

1

4

2

5

3

INTERNET DESIGN

1 **Design Firm** Design Moves, Ltd., Highland Park IL
Client Peters & Associates
Title Web Site
Art Director Laurie Medeiros Freed
Designer William R. Sprowl
Illustrator William R. Sprowl

2 **Design Firm** Dewpoint, Chicago IL
Client Sanford
Title The Relaunch of PaperMate
Art Director Jeff Szucs
Designer Jeff Szucs
Illustrators Tom Elliot, Tim Jacoby
Photographer e-light studios

3 **Design Firm** DVC Worldwide, Morristown NJ
Client Subaru of America
Title Baja Web Site
Art Directors Dustin Young, Michael Pittard
Photographer Evox Productions

4 **Design Firm** Engine Interactive, Seattle WA
Client Zooka Sports Corporation
Title Web Site
Art Director Toan Le
Designers Robin Naughton, Mike Shore

5 **Design Firm** Fathom Creative, Washington DC
Title Web Site
Art Director Drew Mitchell
Designers Maribel Costa, Yael Tamir, Fathom Team

1

2

3

4

5

INTERNET DESIGN

1 **Design Firm** Greenfield/Belser Ltd., Washington DC
Client Day, Berry & Howard LLP
Title Web Site
Art Director Burkey Belser
Designers Liza Corbett, Charlyne Fabi

2 **Design Firm** Hanlon Brown Design, Portland OR
Client Hip Furniture
Title Web Site
Art Director Sandy Brown
Designer Dana Rierson

3 **Design Firm** Jeffrey Leder Inc., New York NY
Client PackAge
Title Web Site
Art Director Jeffrey Leder
Designer Steven Albarracin

4 **Design Firm** Kelley Communications Group, Dublin OH
Client Dublin
Title Teachers Manual
Art Director Kevin Ronnebaum
Designer Beth Czekalski

5 **Design Firm** Kelley Communications Group, Dublin OH
Client Ohio State University Athletics
Title Digital Newsletter
Art Director Kevin Ronnebaum
Designers Allison Rupp, Jamie Havens

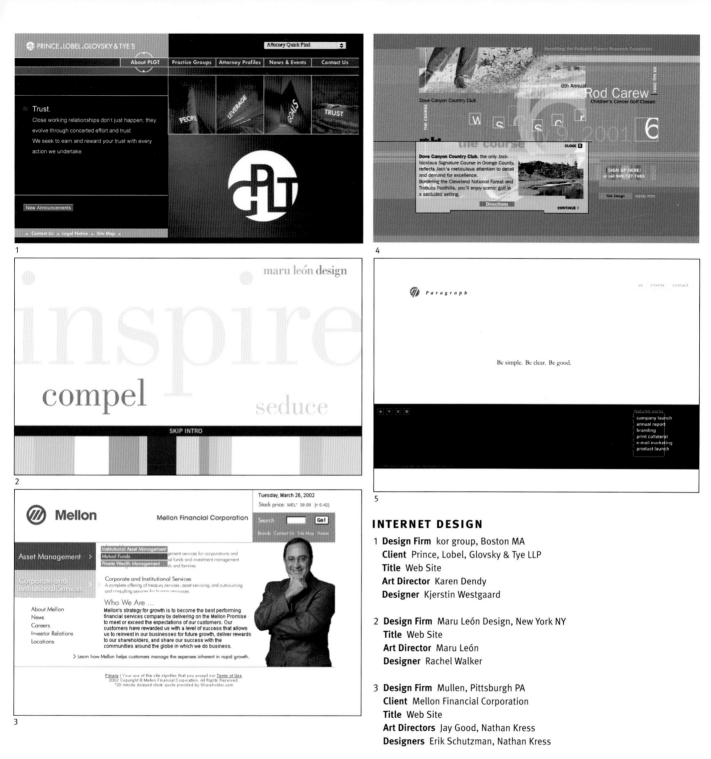

1 **Design Firm** kor group, Boston MA
 Client Prince, Lobel, Glovsky & Tye LLP
 Title Web Site
 Art Director Karen Dendy
 Designer Kjerstin Westgaard

2 **Design Firm** Maru León Design, New York NY
 Title Web Site
 Art Director Maru León
 Designer Rachel Walker

3 **Design Firm** Mullen, Pittsburgh PA
 Client Mellon Financial Corporation
 Title Web Site
 Art Directors Jay Good, Nathan Kress
 Designers Erik Schutzman, Nathan Kress

4 **Design Firm** p11creative, Santa Ana Heights CA
 Client Pediatric Cancer Research Foundation
 Title Rod Carew Children's Cancer
 Golf Classic Web Site
 Creative Director Lance Huante
 Designer Mike Esperanza
 Flash Designer Kriss Brown

5 **Design Firm** Paragraph, Philadelphia PA
 Title Web Site
 Art Director Bob Aretz
 Designer Bob Aretz

117

1

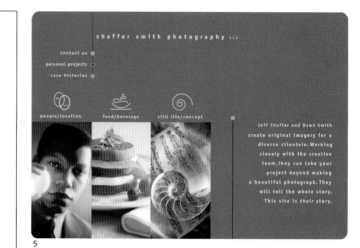

5

2

6

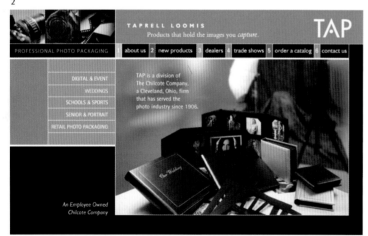

3

INTERNET DESIGN

1 **Design Firm** Patricia Vogt Graphic Design, Chicago IL
Client Common Knowledge Communications
Title Web Site
Art Director Patricia Vogt
Designer Patricia Vogt

2 **Design Firm** Pinkhaus, Miami FL
Client Bacardi USA, Inc.
Title Mojito Mini Web Site
Art Director Rafael Rosa
Designer Rafael Rosa
Copywriter Nathalie Bresztyenszky
Photographer Jill Greenberg

3 **Design Firm** SCK Design Inc., Cleveland OH
Client Taprell Loomis
Title Web Site
Designer Xenia Rivera

4 **Design Firm** Skidmore Inc., Southfield MI
Title Web Site
Art Director Mae Skidmore
Designer Barrett Strev
Photographer Jeff Hargis

5 **Design Firm** Spielman Design, LLC, Collinsville CT
Client Shaffer Smith Photography LLC
Title Web Site
Designer Amanda Bedard
Webmaster Jeff Shaffer

6 **Design Firm** TeleTech Holdings/Spiremedia, Englewood CO
Client TeleTech
Title Web Site
Art Director Geoff Thomas
Designer Geoff Thomas

4

MOTION GRAPHICS

119

3

1

2

4

MOTION GRAPHICS

1 **Design Firm** Adam, Filippo & Associates, Pittsburgh PA
 Client Promistar Financial
 Title TV Spot
 Art Director Robert Adam
 Designer Martin Perez

2 **Design Firm** Archetype Group Inc., Green Bay WI
 Title Evolutionaries Web Site
 Art Directors James Rivett, Paul Meinke
 Designer Jason Davis
 Photographer Steve Eliasen

3 **Design Firm** Black Diamond Concepts, Denver CO
 Client Mountain West Conference
 Title Above the Rest Campaign - Television
 Art Directors Eric Malmstrom, Brian Powers
 Designers Ben Larson, Jake Quick

4 **Design Firm** Division Street Design, Westlake OH
 Title roadtrip
 Art Director Steve Meyer
 Designer Steve Meyer
 Illustrator Steve Meyer

1

2

3

4

MOTION GRAPHICS

1 **Design Firm** Eyeball NYC, New York NY
Client Bravo Network
Title Independent Spirit Awards

2 **Design Firm** Griffith Phillips Creative, Dallas TX
Title Lava Lamp Flash Web Intro
Art Director Kenny Osborne
Designer Kenny Osborne

3 **Design Firm** Imaginary Studio, New York NY
Client Red Flower
Title redflowerworld Web Site
Art Director Stephen Jablonsky
Designer Stephen Jablonsky
Programmer Brian Douglas
Photographer Stephen Jablonsky

4 **Design Firm** Kircher, Washington DC
Client Biotechnology Industry Organization
Title Biojurist.org CD Packaging
Art Director Bruce E. Morgan
Designer Bruce E. Morgan

1

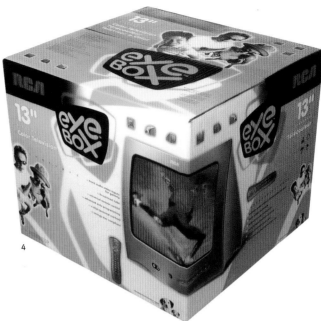

4

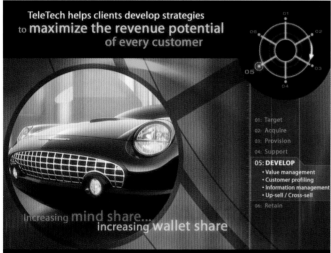

2

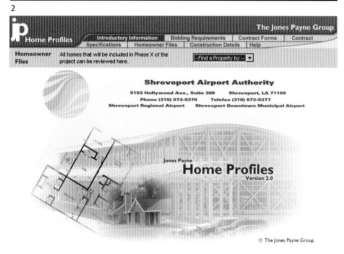

3

MOTION GRAPHICS

1 **Design Firm** Open Eye Design, Inc., Fullerton CA
 Client Sunrider International
 Title Kandesn Interactive CD-Rom
 Art Director Greg Herrington
 Designer Greg Herrington

2 **Design Firm** TeleTech Holdings/Spiremedia, Englewood CO
 Client TeleTech
 Title Lifecycle Video
 Art Directors Kelly Konwinski, Kevin Anderson
 Designers Kelly Konwinski, Kevin Anderson

3 **Design Firm** The Jones Payne Group, Boston MA
 Title Project Portal
 Designer Peter J. Raneri

4 **Design Firm** VMA, Dayton OH
 Client Thomson Multimedia, Inc.
 Title RCA Eyebox-Graphic Packaging
 Art Directors Kenneth Botts, Al Hidalgo
 Designer Al Hidalgo

PACKAGING

123

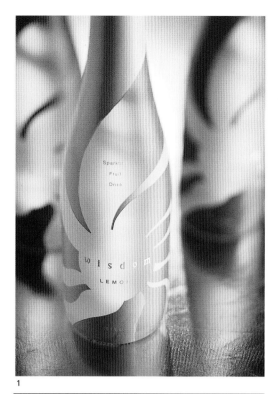

1

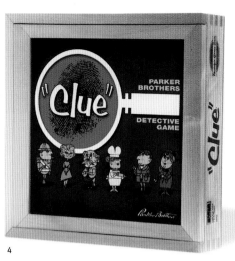

4

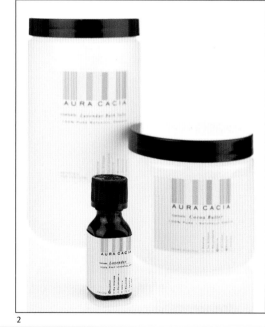

2

PACKAGING

1 **Design Firm** Academy of Art College, San Francisco CA
 Client Asian Art Museum of San Francisco
 Title Wisdom Beverage & Rice Cracker
 Art Director Amy Hershman
 Designer Esther Hong
 Illustrator Esther Hong
 Photographer Woo Kyo Shin

2 **Design Firm** Addis, Berkeley CA
 Client Aura Cacia
 Title Packaging
 Art Director Michael Roché
 Designer Joanne Hom

3 **Design Firm** Addis, Berkeley CA
 Client INOBYS
 Title Frulatté Packaging
 Art Director Joanne Hom
 Designer Joanne Hom
 Photographer Noel Barnhurst

4 **Design Firm** Adrenaline Design, Inc., Manchester MA
 Client Winning Solutions for Hasbro
 Title Nostalgic Game Series
 Art Directors Steve Krupsky, Nan Finkenaur
 Designers Steve Krupsky, Nan Finkenaur
 Photographer Lightstream

5 **Design Firm** Baruch Design Associates, Easton PA
 Client Adams, a division of Pfizer
 Title Dentyne Ice US & Canada
 Art Director Gerri Baruch
 Designer Gerri Baruch
 Illustrator Jack Moore

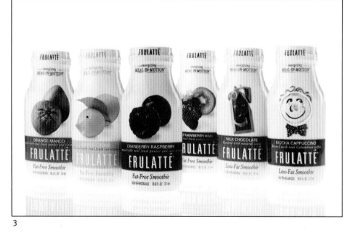

3

5

1

2

3

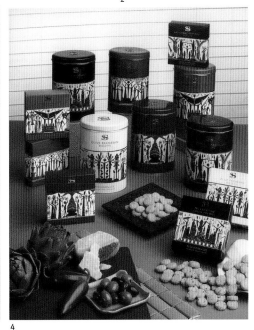

4

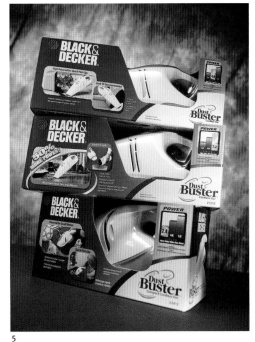

5

PACKAGING

1 **Design Firm** Brown Design & Company,
Portland ME
Client Pemberton's Gourmet Foods
Title Pemberton's Desserts
Art Director Mary Brown
Designer Mary Brown

2 **Design Firm** CAG Design, Hackettstown NJ
Client PNY Technologies, Inc.
Title Verto
Art Director David Motyl
Designer David Motyl

3 **Design Firm** CAG Design, Hackettstown NJ
Client RSI Enterprises
Title Spongetech
Art Director David Motyl
Designer David Motyl

4 **Design Firm** Canyon Creative, Las Vegas NV
Client Byrd Cookie Company
Title Seckinger Lee Gourmet Biscuit Tins
Art Director Dale Sprague
Designers Dale Sprague, Amy Pearce,
David Adler
Illustrator Gerome Temple

5 **Design Firm** Catalpha Advertising & Design,
Towson MD
Client Black & Decker
Title Dust Buster Package
Art Director Karen Kerski
Designers Megan Fitzgerald, Kolleen Kilduff
Photographer Bruce Strange

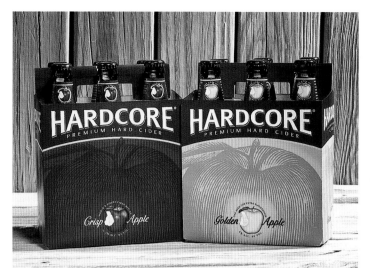

1

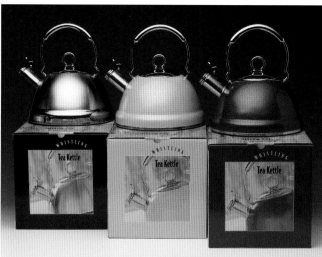

4

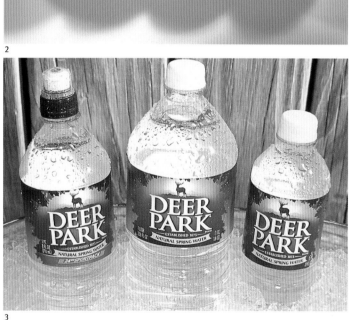

2

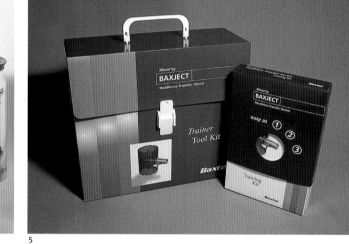

5

PACKAGING

1 **Design Firm** Cornerstone Design Associates, New York NY
 Client Boston Beer Co.
 Title HardCore Cider Packaging Redesign
 Art Director Keith Steimel
 Designer Sarah Sansom

2 **Design Firm** Cornerstone Design Associates, New York NY
 Client Johanna Foods
 Title La Yogurt Redesign
 Art Directors Keith Steimel, Sally Clarke
 Designers Sarah Sansom, Nicole Lipschik
 Illustrator Lori Anzaione

3 **Design Firm** Cornerstone Design Associates, New York NY
 Client Nestlé Waters/N.A.
 Title Deer Park Packaging Redesign
 Art Directors Keith Steimel, Sally Clarke
 Designers Sarah Sansom, Pablo Pineda
 Illustrator David O'Neil

4 **Design Firm** Costco Wholesale, Issaquah WA
 Title Whistling Tea Kettles
 Art Director Shay Quigley
 Designer Marcy Takahashi-Martin
 Photographer Iridio Studios

5 **Design Firm** Design Moves, Ltd., Highland Park IL
 Client Baxter Healthcare Corporation
 Title BAXJECT Trainer Tool Kit
 Art Director Laurie Medeiros Freed
 Designer April D. Beheler

3

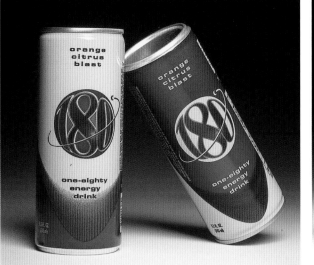

1

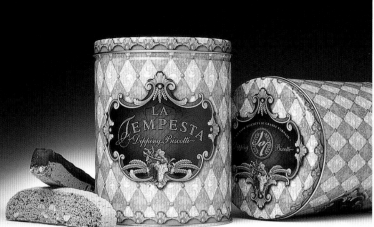

2

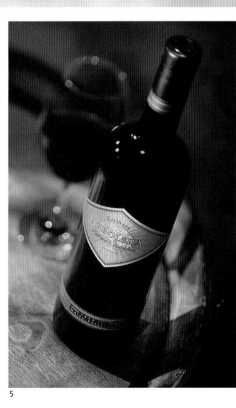

3

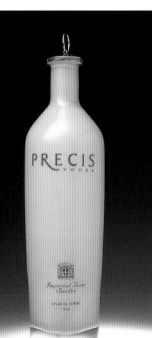

4

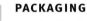

5

PACKAGING

1 **Design Firm** Deutsch Design Works, San Francisco CA
Client Anheuser-Busch Image Development Group
Title one-eighty energy drink
Art Directors Barry Deutsch, John Marota
Designer Gregg Perin

2 **Design Firm** Deutsch Design Works, San Francisco CA
Client La Tempesta Biscotti
Title Holiday Tin
Art Director Barry Deutsch
Designer Lori Wynn

3 **Design Firm** Deutsch Design Works, San Francisco CA
Client Pepsi-Cola Design Group
Title Diet Pepsi
Art Director Barry Deutsch
Designer Eric Pino

4 **Design Firm** Deutsch Design Works, San Francisco CA
Client Precis International
Title Precis Vodka
Art Director Barry Deutsch
Designers Lori Wynn, Mike Kunisaki

5 **Design Firm** Deutsch Design Works, San Francisco CA
Client Robert Mondavi Winery
Title Arboleda Wine
Art Director Barry Deutsch
Designers Dexter Lee, Jacques Rossouw

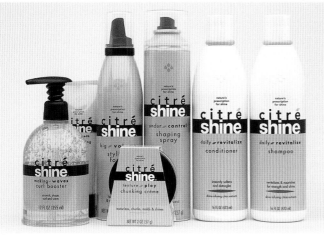

1

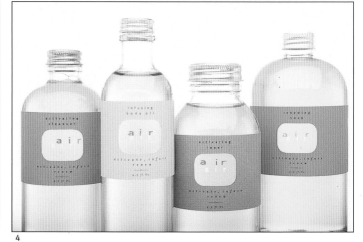

2

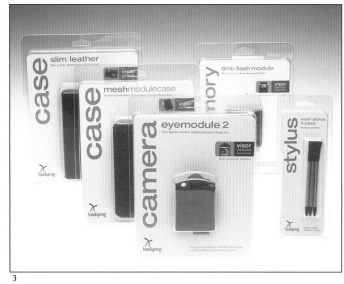

3

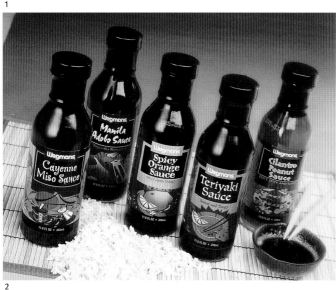

4

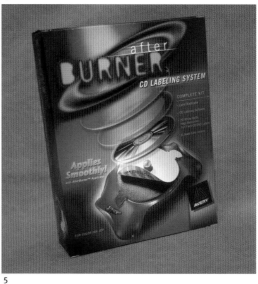

5

PACKAGING

1 **Design Firm** DiDonato Associates, Chicago IL
Client Advanced Research Labs
Title Citré Shine
Creative Director Peter DiDonato
Designers Peter DiDonato, Mike McGlothlin

2 **Design Firm** Dunn and Rice Design, Inc., Rochester NY
Client Wegman's Food Markets
Title Wegman's Far Eastern Dressings
Art Director Clay Girouard
Designer Clay Girouard
Illustrator Clay Girouard

3 **Design Firm** Energy Energy Design, Los Gatos CA
Client Handspring
Title Visor Accessory Packaging
Art Director Leslie Guidice
Designers Stacy Guidice, Jeanette Aramburu

4 **Design Firm** Erbe Design, South Pasadena CA
Client Air
Title Cosmetic Packaging
Art Director Maureen Erbe
Designers Maureen Erbe, Efi Latief

5 **Design Firm** FutureBrand, New York NY
Client Avery Dennison
Title Avery AfterBurner CD Labeling System
Art Director Kenn Lewis
Designers Jillian Mazzacano, Jennifer Katz
Photographer Marc Simon

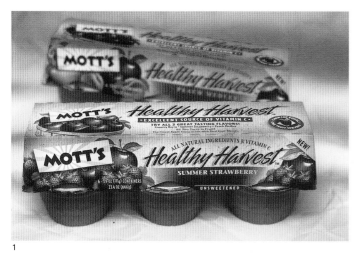

1

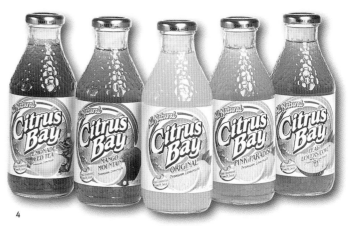

4

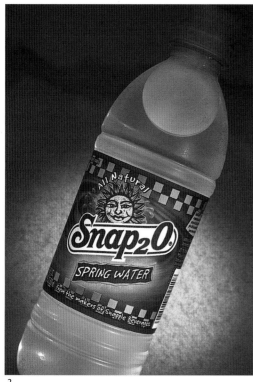

2

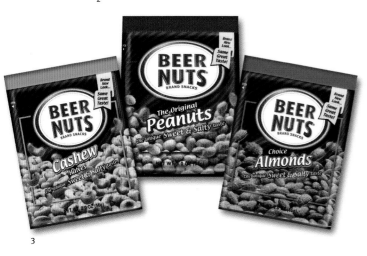

3

PACKAGING

1 **Design Firm** FutureBrand, New York NY
Client Mott's
Title Mott's Healthy Harvest
Art Director Laura Fang
Designer Diane Lamendola
Illustrator J.C. Chou

2 **Design Firm** FutureBrand, New York NY
Client Snapple Beverage Group
Title Snapple Snap2O Spring Water
Art Director Joe Violante
Designer Chris Chevins
Illustrator Mike Wepplo

3 **Design Firm** Gammon Ragonesi Associates, New York NY
Client Beer Nuts
Title Packaging Redesign
Art Director Mary Ragonesi
Designer Alison Marston
Photographer Peter Pioppo

4 **Design Firm** Gammon Ragonesi Associates, New York NY
Client Citrus Bay
Title Lemonade Package Design
Art Director Mary Ragonesi
Designer Sarah Gurland
Illustrator Murray Karn

5 **Design Firm** Gammon Ragonesi Associates, New York NY
Client PET
Title PET Sassers Fruit Drink Package Design
Art Director Mary Ragonesi
Designer Sarah Gurland

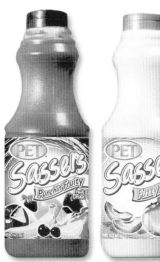

5

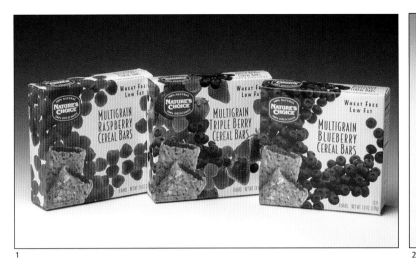

1

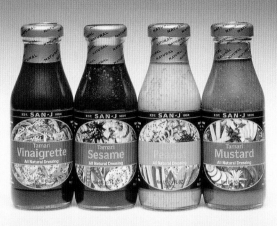

2

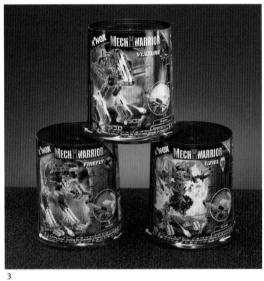

3

4

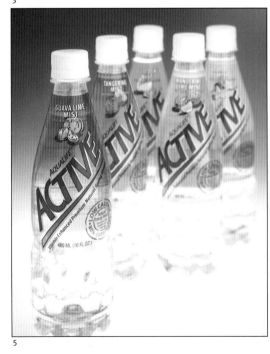

5

PACKAGING

1 **Design Firm** Gauger & Santy, San Francisco CA
 Client Barbara's Bakery
 Title Cereal Bars
 Art Director Isabelle Laporte
 Designer Julie Sforza

2 **Design Firm** Gauger & Santy, San Francisco CA
 Client San-J
 Title Sauces
 Art Director Lori Murphy

3 **Design Firm** Graphicon Studios, Fairless Hills PA
 Client Knex
 Title Mini Mech Warrior
 Art Directors Jim Patella, Joe Morroni
 Designers Joe Morroni, Jim Patella

4 **Design Firm** Graphicon Studios, Fairless Hills PA
 Client Toymax
 Title Dragonfly
 Art Directors Jim Patella, Joe Morroni
 Designers Joe Morroni, Jim Patella

5 **Design Firm** Gunn Design, Boston MA
 Client Avalon Beverage Company
 Title Active
 Art Director Martha Heath
 Designer Martha Heath
 Illustrator Mark Bellerose

1

4

2

3

PACKAGING

1 **Design Firm** Hanson Associates, Philadelphia PA
 Client JPMorgan Fleming
 Title Day in a Box
 Art Director Tobin Beck
 Designer Matt Marhefka

2 **Design Firm** Harman Consumer Group, Woodbury NY
 Client JBL-Car
 Title JBL-Car-GTO Series
 Art Director Mike Keeley
 Designer Robin Witt
 Photographer Josh McClure

3 **Design Firm** Harman Consumer Group, Woodbury NY
 Client JBL-Car
 Title JBL-Car-GT Series
 Art Director Mike Keeley
 Designer Robin Witt
 Photographer Josh McClure

4 **Design Firm** Hughes Design Group, Norwalk CT
 Client Georgia-Pacific Corporation
 Title Vanity Fair Napkins
 Designer Kurt Leunis

5 **Design Firm** Hughes Design Group, Norwalk CT
 Client Just Born, Inc.
 Title Teenee Beanee
 Designer Kurt Leunis
 Illustrator John Youssi

5

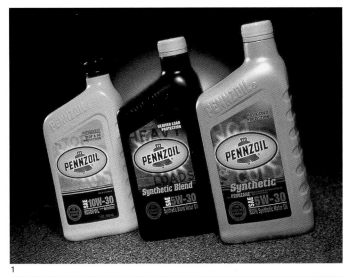

1

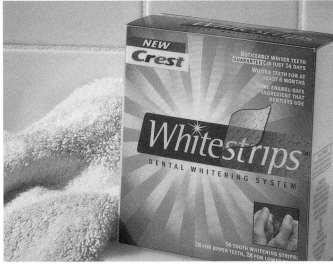

2

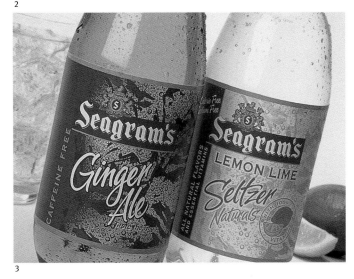

3

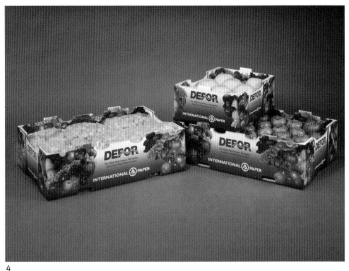

4

PACKAGING

1 **Design Firm** Interbrand, New York NY
 Client Pennzoil
 Title Motor Oil
 Art Director Jeff Zack
 Designer Melissa Mullin

2 **Design Firm** Interbrand, New York NY
 Client Procter & Gamble
 Title Crest Whitestrips
 Art Director Michael Endy
 Designers Seth Walinchus, Melissa Mullin

3 **Design Firm** Interbrand, New York NY
 Client Seagram's
 Title Seagram's Mixers
 Art Director Michael Endy
 Designers Francine Germano, Melissa Mullin

4 **Design Firm** International Paper, Memphis TN
 Title DEFOR Produce Display Tray
 Art Director Roger Rasor
 Designer Terry Jarred
 Photographer Jim Kiihnl

5 **Design Firm** International Paper, Memphis TN
 Client DeWitt Produce Company
 Title Cucumber Packaging
 Art Director Roger Rasor
 Designer Shea Morgan
 Illustrators Carrie Kish, Terry Jarred

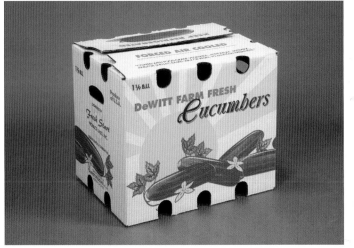

5

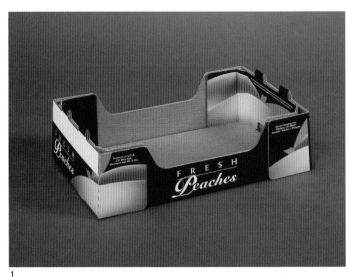

1

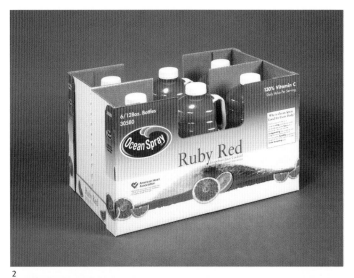

2

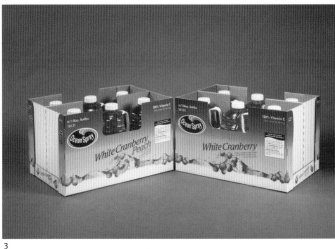

3

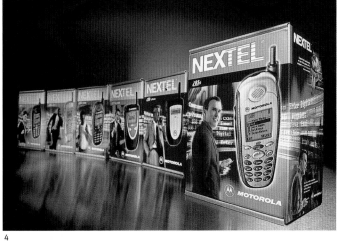

4

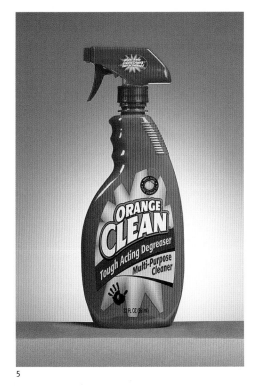

5

PACKAGING

1 **Design Firm** International Paper, Memphis TN
 Client Fowler Packing Co.
 Title Peach DEFOR
 Art Director Roger Rasor
 Designer Shea Morgan
 Illustrator Shea Morgan

2 **Design Firm** International Paper, Memphis TN
 Client Ocean Spray
 Title Ruby Red Juice Display Packaging
 Art Director Roger Rasor
 Designer Terry Jarred

3 **Design Firm** International Paper, Memphis TN
 Client Ocean Spray
 Title White Cranberry Juice Display Packaging
 Art Director Roger Rasor
 Designer Terry Jarred

4 **Design Firm** Keck Garrett Advertising, Chicago IL
 Client Nextel Communications
 Title Packaging
 Art Director Cher Garrett
 Designer Leanne Lally
 Photographer Steve Garrett Photography

5 **Design Firm** Keck Garrett Advertising, Chicago IL
 Client Orange Glo International
 Title Orange Clean Package
 Art Director Cher Garrett
 Designer Shelbi Gabriel

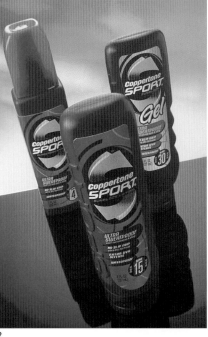

1

2

3

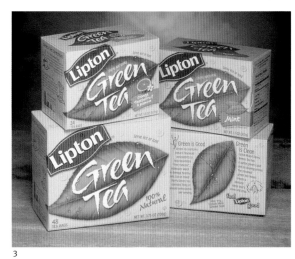

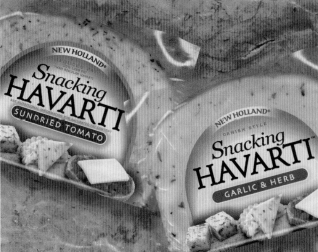

4

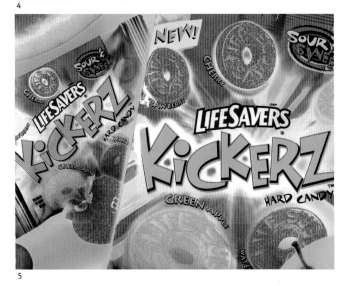

5

PACKAGING

1 **Design Firm** LIFT Packaging & Promotion Creatives, Inc. ,
Atlanta GA
Client Dr. Pepper/ 7 Up
Title Crush Package Redesign
Art Director Jane Coker
Designer Rich Linden
Illustrator Rich Linden

2 **Design Firm** Lipson Alport Glass, Northbrook IL
Client Schering-Plough
Title Coppertone Sport
Art Director Rob Swan
Designer Mark Krukonis

3 **Design Firm** Lipson Alport Glass, Northbrook IL
Client Unilever Best Foods
Title Lipton Green Tea
Art Director Rob Swan
Designers Mark Krukonis, Walter Perlowski

4 **Design Firm** LMS Design, Stamford CT
Client BC USA
Title Havarti
Art Director Richard Shear
Designer Richard Shear
Photographer Karen Heerlein

5 **Design Firm** LMS Design, Stamford CT
Client Nabisco
Title LifeSavers Kickerz
Art Director Alex Williams
Designer Richard Shear
Illustrator John Rosenbaum

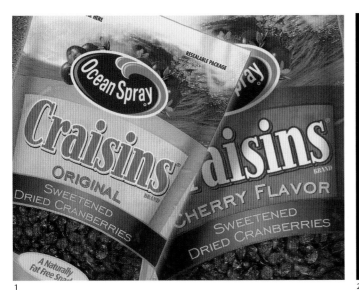

1

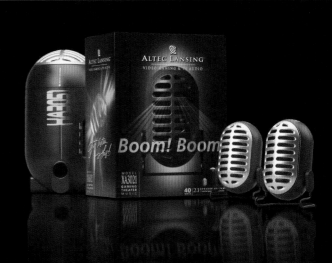

2

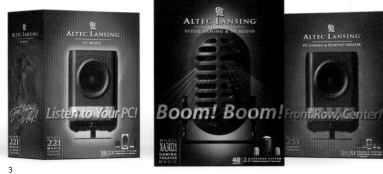

3

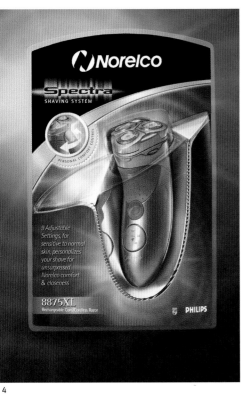

4

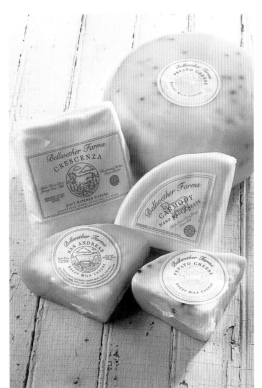

5

PACKAGING

1 **Design Firm** LMS Design, Stamford CT
Client Ocean Spray
Title Craisins
Art Director Richard Shear
Designer Richard Shear

2 **Design Firm** Macey Noyes Associates, Wilton CT
Client Altec Lansing
Title Speakers Packaging
Designers Macey Noyes Associates

3 **Design Firm** Macey Noyes Associates, Wilton CT
Client Altec Lansing
Title 2002 Speaker Package Line
Designers Macey Noyes Associates

4 **Design Firm** Macey Noyes Associates, Wilton CT
Client Norelco
Title Spectra Shaving System
Designers Macey Noyes Associates

5 **Design Firm** Mark Oliver, Inc., Solvang CA
Client Bellwether Farms
Title Bellwether Cheeses
Art Director Mark Oliver
Designers Mark Oliver, Patty Driskel
Illustrator Sudi McCollum

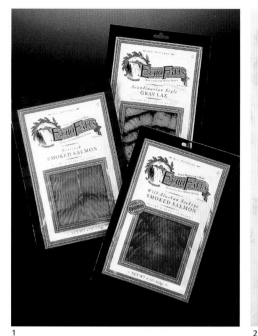

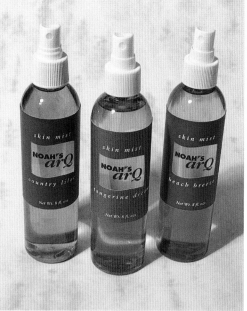

PACKAGING

1 **Design Firm** Mark Oliver, Inc., Solvang CA
Client Ocean Beauty Seafood
Title Echo Falls
Art Director Mark Oliver
Designers Mark Oliver, Patty Driskel
Illustrator Harry Bates

2 **Design Firm** Out of the Box, Fairfield CT
Client Reviva Corp.
Title Noah's ArQ Body Mists
Art Director Rick Schneider
Designer Rick Schneider
Illustrator Rick Schneider

3 **Design Firm** Out of the Box, Fairfield CT
Client SFactor
Title Joint and Muscle Mineral Herb Spa
Art Director Rick Schneider
Designer Rick Schneider
Photographer George Clemons

4 **Design Firm** Out of the Box, Fairfield CT
Client Tenga Co.
Title Cocoa Bars
Art Director Rick Schneider
Designer Rick Schneider
Photographer Frank Thomas

5 **Design Firm** Paragraph, Philadelphia PA
Client Foster's
Title Foster's Urban Bags
Art Director Bob Aretz
Designer Nicole Brouse

1

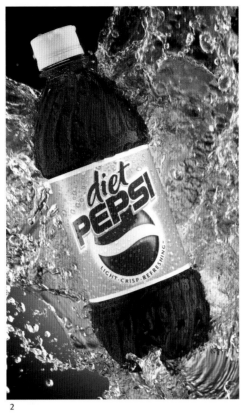

2

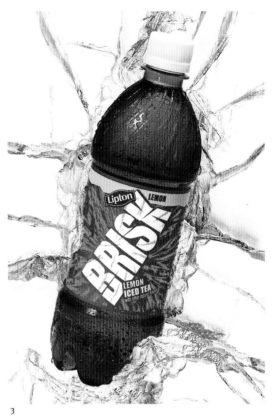

3

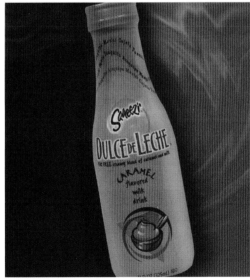

4

PACKAGING

1 **Design Firm** Pepsi-Cola Company, Purchase NY
Title AMP Energy Drink
Art Director Ron Udiskey

2 **Design Firm** Pepsi-Cola Company, Purchase NY
Title Diet Pepsi Redesign
Art Directors Marion Schneider, Sherry Voytek
Designer Deutsch Design Works
Photographer John Mierisch

3 **Design Firm** Pepsi-Cola Company, Purchase NY
Title Lipton Brisk Redesign
Art Directors Marion Schneider, Sherry Voytek
Designers Sterling Group
Photographer John Mierisch

4 **Design Firm** S2 design Group, New York NY
Client Brooklyn Bottling
Title Squeezr Dulce de Leche
Art Director Eileen Strauss
Designers Eileen Strauss
Illustrator Philip Yip

5 **Design Firm** S2 design Group, New York NY
Client Colgate Palmolive
Title Lady Speed Stick Clean Glide
Art Director Eileen Strauss
Designer Eileen Strauss

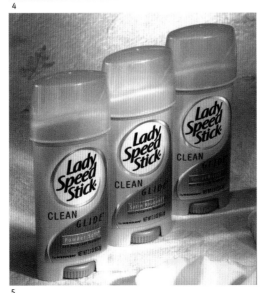

5

4

1

2

5

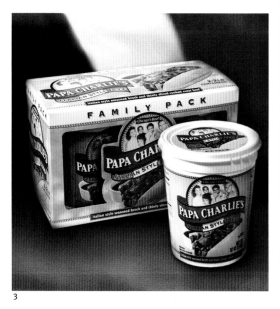

3

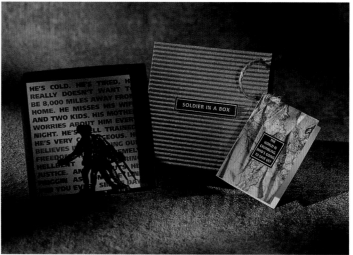

6

PACKAGING

1 **Design Firm** Schilson Design, St. Louis MO
Client Farshid Etniko
Title Nightmare in Heaven CD
Art Director Amie Schilson
Designer Amie Schilson
Illustrator Amie Schilson

2 **Design Firm** Signature Communications, Philadelphia PA
Client Motorola
Title simplefi Packaging
Art Director Darren Hoffman
Designer Darren Hoffman
Illustrator Darren Hoffman
Photographer John Carlano

3 **Design Firm** Source/Inc., Chicago IL
Client Papa Charlie's
Title Packaging
Art Director Scott Burns
Designer Adrienne Nole

4 **Design Firm** Source/Inc., Chicago IL
Client Solo
Title Solo Cups & Plates
Designer Scott Burns

5 **Design Firm** Source/Inc., Chicago IL
Client Waterpik Technologies
Title Aquia Sanitizing System
Art Director Adrienne Nole
Designer Sabrina Chan
Illustrators Andrew Sechin, Sabrina Chan
Photographers Fritz Geiger, Hot Shots Imaging

6 **Design Firm** Sunspots Creative, Inc. Hoboken NJ
Client Jar Yer Memory Gifts
Title Soldier in a Box
Art Director Rick Bonelli
Designer Deena Hartley
Photographer Sandy Burstein

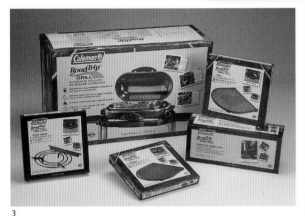

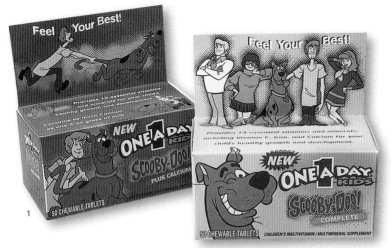

PACKAGING

1 **Design Firm** Szylinski Associates, Inc.,
New York NY
Client Bayer Corporation
Title One-A-Day Kids
Scooby-Doo Vitamins
Art Director Ed Szylinski
Designer Ed Szylinski

2 **Design Firm** Szylinski Associates, Inc.,
New York NY
Client Bayer Corporation
Title Walgreen's 100th Anniversary
Bayer Aspirin
Art Director Ed Szylinski
Designer Ed Szylinski

3 **Design Firm** The Coleman Company, Inc.,
Wichita KS
Title Roadtrip Packaging
Art Directors Mat Cornejo, Brent Ward
Designer Dunn Allen Design
Photographer Paul Chauncey

4 **Design Firm** The Sloan Group,
New York NY
Client A&E
Title Peter Gunn
Art Directors Rita Arifin,
Sandra Nevistich

5 **Design Firm** The Stanley Works,
New Britain CT
Client Stanley Hand Tools
Title AntiVibe Hammer Package
Art Director Randy Richards
Designer Daniel Deming
Photographer Bruno Ratensperger

6 **Design Firm** The Stanley Works,
New Britain CT
Client Stanley Hand Tools
Title FatMax Blade Armor Package
Art Director Randy Richards
Designer Melissa Garrett
Illustrator Melissa Garrett
Photographer Bruno Ratensperger

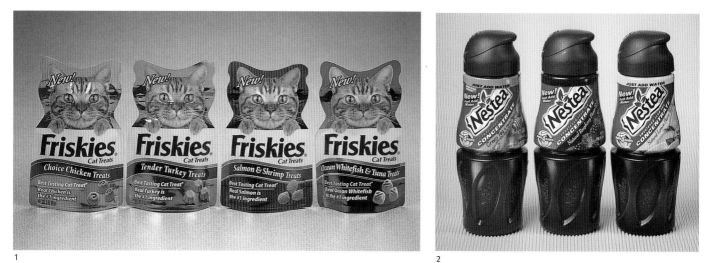

1

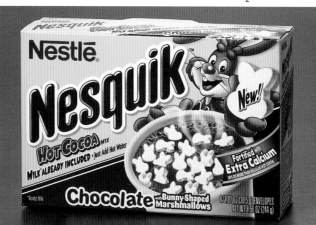

3

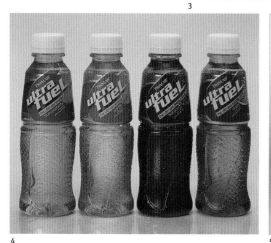

4

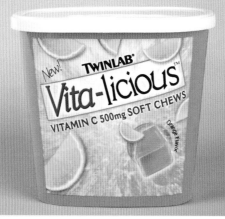

5

2

PACKAGING

1 **Design Firm** Thompson Design Group,
San Francisco CA
Client Nestlé Purina PetCare Company
Title Friskies Cat Treats Pouch
Art Directors Dennis Thompson,
Dan Bishop
Designer Patrick Fraser
Illustrator Dennis Mosner
Photographer Dennis Mosner,
Trafficanda Studios

2 **Design Firm** Thompson Design Group,
San Francisco CA
Client Nestlé USA, Inc. -
Beverage Division
Title Nestea Concentrate
Art Directors Dennis Thompson,
Dan Bishop
Designer Patrick Fraser
Illustrator Ben Garvie

3 **Design Firm** Thompson Design Group,
San Francisco CA
Client Nestlé USA, Inc. -
Beverage Division
Title Nesquik Hot Cocoa
Art Director Dennis Thompson
Designer Dan Bishop
Illustrator Ramon Casanyes

4 **Design Firm** Twinlab Design Group,
Hauppauge NY
Client Twinlab
Title Ultra Fuel
Art Director Chris Harri
Designer Chris Harri

5 **Design Firm** Twinlab Design Group,
Hauppauge NY
Client Twinlab
Title Vita-licious
Art Director Lauren Smith
Designer Lauren Smith

6 **Design Firm** Yamamoto Moss,
Minneapolis MN
Client Activision
Title Big Air Wakeboarding
Art Director Joan Frenz
Designer Lauren Nicole

6

P-O-P/SIGNS/DISPLAYS

141

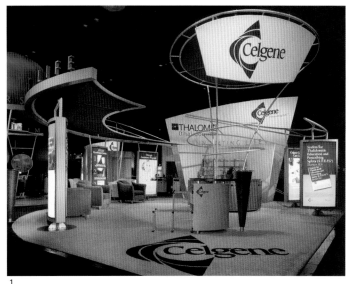

1

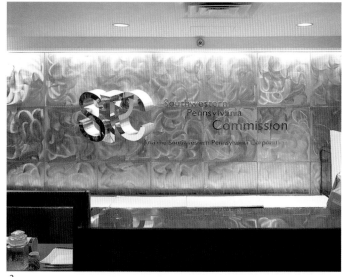

2

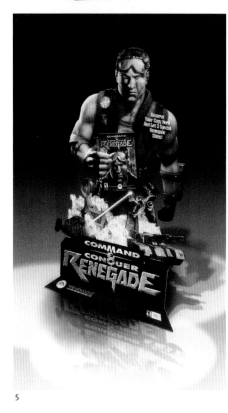

3

4

5

P-O-P/SIGNS/DISPLAYS

1 **Design Firm** Access TCA, Whitinsville MA
 Client Celgene Corporation
 Title American Society of Hematology
 Art Director Jack Hyndman, Palio Communications
 Designer Kevin Peetz
 Photographer Jamie Padgett

2 **Design Firm** Adam, Filippo & Associates, Pittsburgh PA
 Client Southwestern Pennsylvania Commission
 Title Sign
 Art Director Robert Adam
 Designer Robert Adam

3 **Design Firm** Catalpha Advertising & Design, Towson MD
 Client Black & Decker
 Title P-O-P In Store Display
 Art Director Karen Kerski
 Designer Kolleen Kilduff
 Photographer Bruce Strange Studios

4 **Design Firm** Crawford/Mikus Design, Inc., Atlanta GA
 Client AWI
 Title Tradebooth
 Art Director Elizabeth Crawford
 Designer Michelle May

5 **Design Firm** Creative Dynamics, Inc., Las Vegas NV
 Client Westwood Studios
 Title Renegade P-O-P Standee
 Art Directors Eddie Roberts, Victoria Hart
 Designer Eddie Roberts

2

1

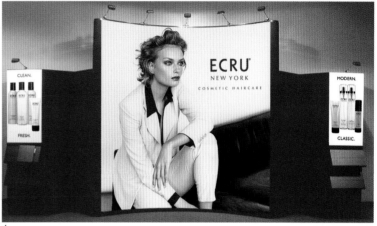

4

3

P-O-P/SIGNS/DISPLAYS

1 **Design Firm** Dart Design, Fairfield CT
Client Tetley USA
Title Urn Wrap
Designer David Anderson
Photographer Bob Grier

2 **Design Firm** DCI Marketing, Milwaukee WI
Client General Motors - Pontiac
Title Product Information Center
Art Director Tom Bruckbauer
Designer Tom Bruckbauer
Illustrator Julie Schweitzer

3 **Design Firm** Dennis Moran Design, Scenery Hill PA
Client Mercy Hospital
Title 150th Anniversary Exhibit
Art Director Dennis Moran
Designer Dennis Moran
Photographers Lynn Johnson,
Scott Goldsmith

4 **Design Firm** DePasquale Companies, Fairlawn NJ
Client ECRU New York
Title Trade Show Booth 2002
Art Director Megan Grand
Designer Megan Grand
Photographer Michael Williams

5 **Design Firm** Eagleye Creative, Littleton CO
Client Chi-Chi's
Title New Chi-Chi's Cosmopolitan
Art Director Todd McGowen
Illustrator Steve Schader

5

1

4

2

5

3

P-O-P/SIGNS/DISPLAYS

1 **Design Firm** Eyeball NYC, New York NY
Client Nike
Title Hyperflight

2 **Design Firm** Gammon Ragonesi Associates, New York NY
Client Nestlé Ice Cream Co.
Title Ice Screamers Promotion Decal
Art Director Mary Ragonesi
Designer J.P. Forbes
Illustrator Mike Wepplo

3 **Design Firm** Gammon Ragonesi Associates, New York NY
Client Nestlé Ice Cream Co.
Title Häagen-Dazs Champion Table Tent
Art Director Mary Ragonesi
Designer Sarah Gurland
Photographer Peter Pioppo

4 **Design Firm** Gammon Ragonesi Associates, New York NY
Client Nestlé Ice Cream Co.
Title Häagen-Dazs
Art Director Mary Ragonesi
Designer J.P. Forbes
Photographer Peter Pioppo

5 **Design Firm** Gammon Ragonesi Associates, New York NY
Client Nestlé Ice Cream Company
Title Freezers Design
Art Director Mary Ragonesi
Designer Jill Schellhorn

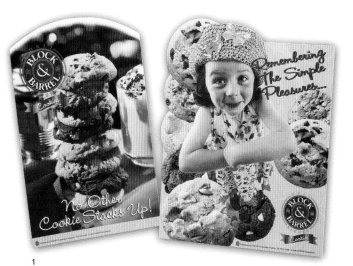

1

4

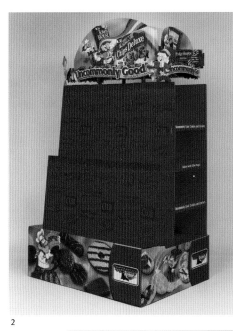

2

P-O-P/SIGNS/DISPLAYS

1 **Design Firm** iDesign, Seymour CT
Client Readi-Bake, Inc.
Title SYSCO Block & Barrel Cookies
Creative Director Lisa Viarengo
Art Director Nicole Fitzgerald
Designer Nicole Fitzgerald
Project Manager Lisa Viarengo
Copywriter Lisa Viarengo
Photographer Jon Van Gorder, Van Gorder Studios, Inc.

2 **Design Firm** Launch Creative Marketing, Hillside IL
Client Keebler Company
Title Uncommonly Good Corrugated End Cap
Art Director Michelle Morales
Designer Michelle Morales
Illustrator Harry Moore
Photographer Alter Image

3 **Design Firm** Medallion Associates, New York NY
Client Foot Locker
Title Nike Tn Air Campaign
Art Director Jodi Schwartz
Designers Mary Studer, JP Terlizzi
Photographer Jonathan Orenstein

4 **Design Firm** Medallion Associates, New York NY
Client Foot Locker
Title Limited Edition
Art Director JP Terlizzi
Designer JP Terlizzi

5 **Design Firm** Pinkhaus, Miami FL
Client Bacardi USA, Inc.
Title Mojito Billboard
Art Director Joel Fuller
Designer Rafael Rosa
Production Manager Suzanne Bernstein
Copywriter Frank Cunningham
Photographer Jill Greenberg

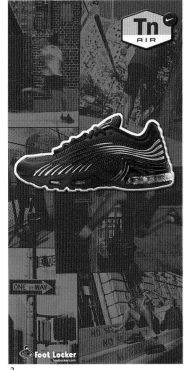

3

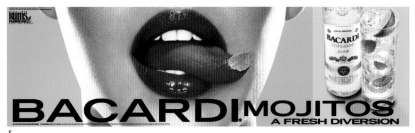

5

1

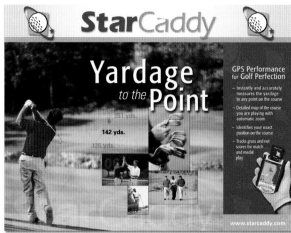

2

3

4

5

P-O-P/SIGNS/DISPLAYS

1 **Design Firm** Roher/Sprague Partners, Irvington NY
Client The New York Historical Society
Title Exhibit Graphics
Art Director Melanie Roher
Designers Melanie Roher, Adam Lein, Christine Sturmer

2 **Design Firm** Serendipity Communications, Christiansburg VA
Client Wall Technology Systems Inc.
Title Trade Show Roll-Ups
Art Director Jennifer Yax
Designer Jennifer Yax
Photographer Richard Boyd

3 **Design Firm** SilverSpur Creative Group, Inc., Norwalk CT
Client Links Point, Inc.
Title StarCaddy Signage
Art Director Peter Skowronski
Designer Peter Skowronski

4 **Design Firm** The Coleman Company, Inc., Wichita KS
Title 9000i Point-of-Purchase
Art Director Mat Cornejo
Senior Designer Carrie Barnes
Photographer Steve Gerig

5 **Design Firm** The Stanley Works, New Britain CT
Client Stanley Hand Tools
Title LeverLock Display
Art Director Randy Richards
Designers Melissa Garrett, Richard Hart
Illustrator Richard Hart
Photographer Bruno Ratensperger

POSTERS

147

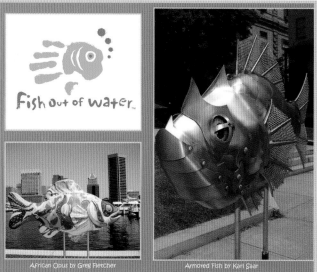

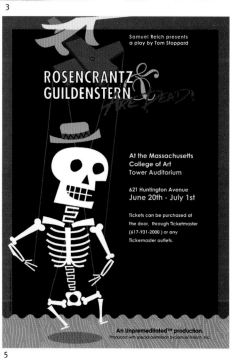

POSTERS

1 **Design Firm** Addison, New York NY
Title Poster
Art Director David Kohler
Designer John Moon

2 **Design Firm** Baltimore Area Convention
and Visitors Association, Baltimore MD
Client Fish Out of Water
Title Poster
Designer Georganne Cammarata
Photographer Pat Venturino

3 **Design Firm** Berry Design, Alpharetta GA
Client Popeyes Chicken & Biscuits
Title 30th Anniversary Poster
Art Director Bob Berry
Designer Bob Berry

4 **Design Firm** Blue Cross Blue Shield of
Rhode Island, Providence RI
Title Control
Art Director Jeff Dahlberg
Designer Jeff Dahlberg
Photographer Michael Indresano

5 **Design Firm** CA Design, Stoneham MA
Client Unpremeditated Productions
Title Rosencrantz & Guildenstern Are
Dead Poster
Art Director Cheryl Allen Forziati
Designer Cheryl Allen Forziati
Illustrator Tony Persiani

1

2

4

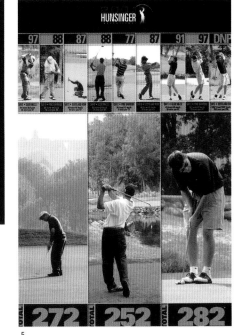

3

5

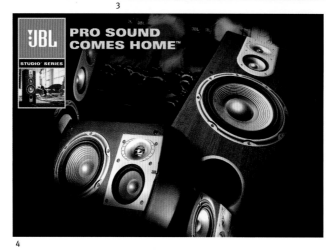

1

2

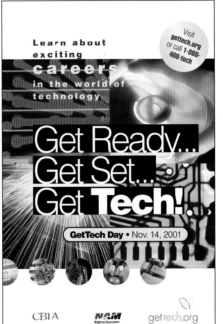

3

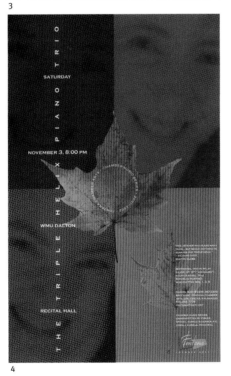

4

5

POSTERS

1 **Design Firm** Industrial Strength Advertising,
Calabasas CA
Client City of Fullerton
Title Shadow Man
Art Director Rick Allen
Designer Rick Allen

2 **Design Firm** International Paper, Memphis TN
Title PMA Expo Souvenir Poster
Art Director Roger Rasor
Designer Roger Rasor
Illustrator Charlie Mitchell

3 **Design Firm** John Kallio Graphic Design,
New Haven CT
Client Connecticut Business and Industry
Association
Title GetTech Day Poster
Art Director John Kallio
Designer John Kallio

4 **Design Firm** John Townsend Graphic Design,
Kalamazoo MI
Client Fontana Chamber Arts
Title Triple Helix Piano Trio
Designer John Townsend

5 **Design Firm** John Townsend Graphic Design,
Kalamazoo MI
Client Kalamazoo College
Title What Matters to Me
Designer John Townsend

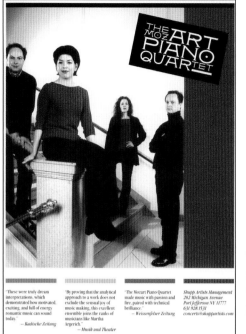

1

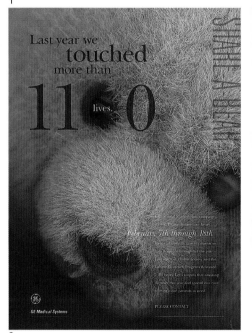

3

2

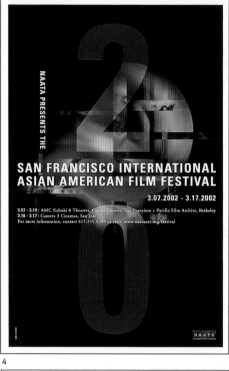

4

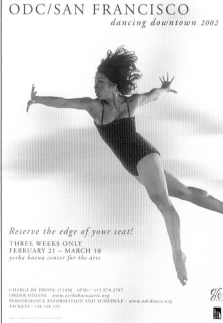

5

6

1

2

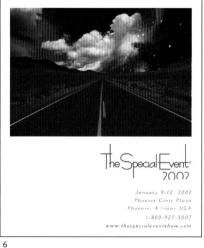

3

4

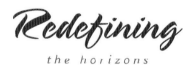

5

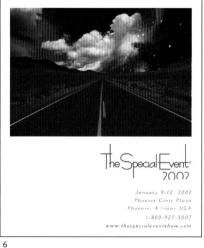

6

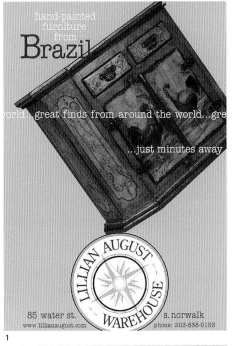

1

2

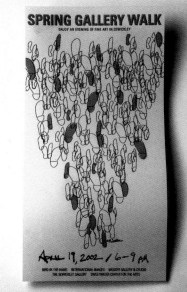

3

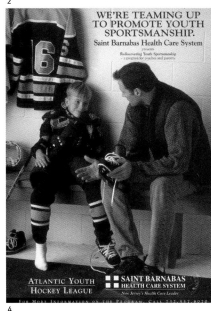

4

5

6

154

PUBLIC SERVICE/PRO BONO

155

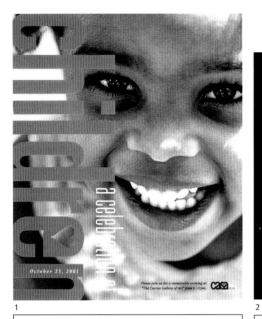

1

2

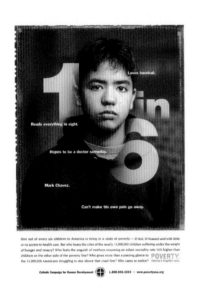

3

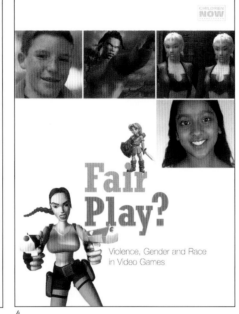

4

5

PUBLIC SERVICE/PRO BONO

1 **Design Firm** Brown & Company Design,
Portsmouth NH
Client CASA of NH
Title Poster
Art Director David Markovsky
Designers Tricia Miller, David Markovsky

2 **Design Firm** Clark Creative Group,
San Francisco CA
Client Huckleberry Youth Programs
Title Web Site
Art Director Annemarie Clark
Designer Doug Da Silva

3 **Design Firm** Crosby Marketing
Communications, Annapolis MD
Client Catholic Campaign for
Human Development
Title 1 in 6 PSA Campaign
Art Director Ron Ordansa
Designer Ron Ordansa
Photographer Peter Howard

4 **Design Firm** Dennis Johnson Design,
Oakland CA
Client Children Now
Title Fair Play? Violence, Gender & Race
in Video Games
Art Director Dennis Johnson
Designers Dennis Johnson, Ted Szeto

5 **Design Firm** Division Street Design,
Westlake OH
Client Norwalk Furniture
Title Century 2002
Art Director Cynthia Peterson
Designer Cynthia Peterson

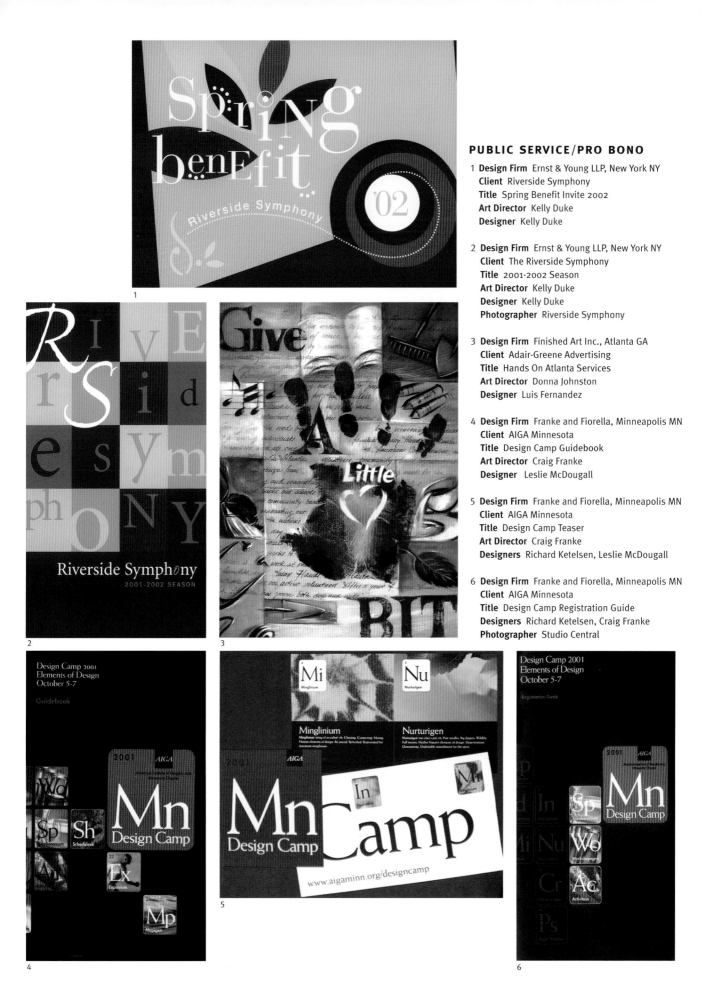

1 **Design Firm** Ernst & Young LLP, New York NY
Client Riverside Symphony
Title Spring Benefit Invite 2002
Art Director Kelly Duke
Designer Kelly Duke

2 **Design Firm** Ernst & Young LLP, New York NY
Client The Riverside Symphony
Title 2001-2002 Season
Art Director Kelly Duke
Designer Kelly Duke
Photographer Riverside Symphony

3 **Design Firm** Finished Art Inc., Atlanta GA
Client Adair-Greene Advertising
Title Hands On Atlanta Services
Art Director Donna Johnston
Designer Luis Fernandez

4 **Design Firm** Franke and Fiorella, Minneapolis MN
Client AIGA Minnesota
Title Design Camp Guidebook
Art Director Craig Franke
Designer Leslie McDougall

5 **Design Firm** Franke and Fiorella, Minneapolis MN
Client AIGA Minnesota
Title Design Camp Teaser
Art Director Craig Franke
Designers Richard Ketelsen, Leslie McDougall

6 **Design Firm** Franke and Fiorella, Minneapolis MN
Client AIGA Minnesota
Title Design Camp Registration Guide
Designers Richard Ketelsen, Craig Franke
Photographer Studio Central

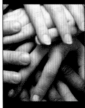

1 **Design Firm** Franke and Fiorella,
Minneapolis MN
Client AIGA Minnesota
Title Design Camp 2001 Logo
Art Director Craig Franke
Designer Leslie McDougall

2 **Design Firm** Franke and Fiorella,
Minneapolis MN
Client AIGA Minnesota
Title Design Camp Coasters
Art Director Craig Franke
Designer Leslie McDougal

3 **Design Firm** Generator Studios,
West Chester PA
Client The Turks Head Clan
Title Medal Display Case Scene
Art Director Rich Hunsinger
Designer Rich Hunsinger
Illustrator Rich Hunsinger

4 **Design Firm** Griffith Phillips Creative,
Dallas TX
Client March of Dimes
Title Flash email
Art Director Bo McCord
Designer Cord Mitchell

5 **Design Firm** Im-aj Communications &
Design, Inc., West Kingston RI
Client Providence School Department
Title READY (Raising Expectations and
Discovering Our Youth)
Art Director Jami Ouellette
Designers Jami Ouellette, Tyler Hall,
Mark Bevington
Photographer Jonathan Flynn

6 **Design Firm** Mullen, Pittsburgh PA
Client Community Technical
Assistance Center
Title Web Site
Art Directors Jay Good, Nathan Kress
Designers Erik Schutzman, Nick Cobler

1

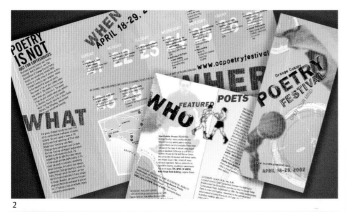

2

3

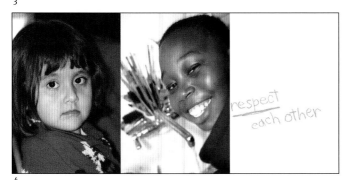

4

1 **Design Firm** North Castle Design,
Stamford CT
Client Purdue Pharma
Title Painfully Obvious Materials
Art Director Kit Campbell
Designers John Ferris, Rudy Mossa

2 **Design Firm** p11creative, Santa Ana
Heights CA
Client 1st Annual Orange County
Poetry Festival
Title Festival Brochure
Creative Director Lance Huante
Designer Alex Chao

3 **Design Firm** Pinkhaus, Miami FL
Client Wolfsonian Institute
Title Artful Truth Blast Package
Art Director Carlos Perez
Designer Mark Cantor
Production Manager Suzanne Bernstein

4 **Design Firm** Pivot Design, Inc.,
Chicago IL
Client Umbrella Tree Studio
Title Brochure
Art Director Brock Haldeman
Designer Melissa Hersam

5 **Design Firm** Sayles Graphic Design,
Des Moines IA
Client Art Fights Back
Title Public Service
Art Director John Sayles
Designers John Sayles, Som Inthalangsy
Illustrator John Sayles

6 **Design Firm** Stiles Corporation,
Fort Lauderdale FL
Client Jack and Jill Children's Center
Title Complete Package
Art Director Nancy Brusher
Designer Stiles Marketing
Illustrator Stiles Marketing
Photographer Stiles Marketing

5

6

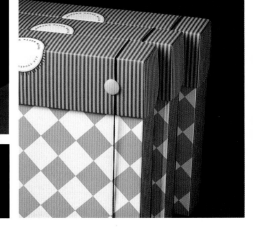

SALES PROMOTION

160

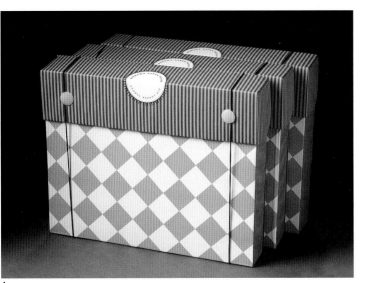

1

2

3

SALES PROMOTION

1 **Design Firm** Aurora Design, Niskayuna NY
Client Mohawk Paper Mills, Inc.
Title Annual Report Kit
Designer Jennifer Wilkerson

2 **Design Firm** Bigfoot Interactive &
rpinteractive, New York NY
Client Honda
Title Civic Si Launch
Creative Director M. Deirdre Namur
Designer Jaime Senior
Copy Emily Spilko
Coding AJ Naito, Greg Ng

3 **Design Firm** Bigfoot Interactive,
New York NY
Client World Wildlife Fund
Title Traffic Appeal
Creative Director M. Deirdre Namur
Designer Jaime Senior
Copy Emily Spilko
Coding AJ Naito, Greg Ng

4 **Design Firm** Courtney & Company,
New York NY
Client The Residences at The Ritz Carlton,
Grand Cayman
Title Marketing Kit
Art Director Tristen Lee George
Designer Tristen Lee George

5 **Design Firm** Courtney & Company,
New York NY
Client Trip.com
Title Media Kit
Art Director Tristen Lee George
Designer Willie Petersen

4

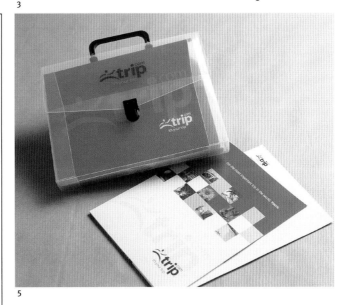

5

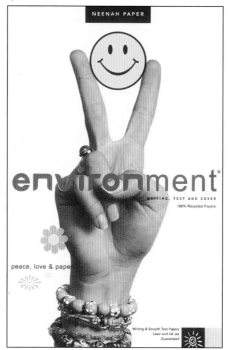

SALES PROMOTION

1 **Design Firm** Creative Intelligence, Inc.,
Los Angeles CA
Client La Perla Boutique
Title Privilege Shopper
Card Promotion
Creative Director Marc Friedland
Designers Bridgette Kloecker,
Spencer Cross, Tammie Abel

2 **Design Firm** Creative Intelligence, Inc.,
Los Angeles CA
Client Rodale Press/Organic Style
Title Launch Experience
Creative Director Marc Friedland
Designers Bridgette Kloecker,
Spencer Cross

3 **Design Firm** EM2 Design, Decatur GA
Client Neenah Paper
Title Classic Crest Papers Campaign
Art Director Maxey Andress
Designer Ellie McKenzie
Photographer Studio Burns

4 **Design Firm** EM2 Design, Decatur GA
Client Neenah Paper
Title Think Ink
Art Director Ellie McKenzie
Designer Tanya Mykytka
Photographer Studio Burns

5 **Design Firm** EM2 Design, Decatur GA
Client Neenah Paper
Title Environment Papers Campaign
Art Director Maxey Andress
Designer Ellie McKenzie
Photographer Studio Burns

1

2

3

4

5

SALES PROMOTION

1 **Design Firm** Fairchild Publications, Inc.
B2B Marketing Group, New York NY
Titles DNR Media Kit, SN Media Kit,
InFurniture Media Kit, Executive
Technology Media Kit
Creative Director Robert Kline
Art Directors Fang Zhou, Candace Corlett
Copywriter David Clark

2 **Design Firm** GraphicVision Design Studios,
Fort Lauderdale FL
Client iSoftel
Title Millenia Software Promotion
Art Director Elsy Aumann
Designer Elsy Aumann

3 **Design Firm** Hanlon Brown Design,
Portland OR
Client Tektronix
Title Drive for the Green
Art Director Theresa Kosztics
Designers Cindy Brandt, Theresa Kosztics

4 **Design Firm** JDG Communications, Inc.,
Falls Church VA
Client Chromagraphics, Inc.
Title Delicious 2002 Calendar
Designers JDG Team
Photographer Taranz

5 **Design Firm** Kelley Communications
Group, Dublin OH
Client Avada
Title Campaign Elements and Multimedia
Art Director Kevin Ronnebaum
Designer Allison Rupp

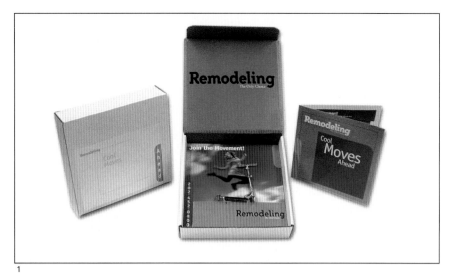

SALES PROMOTION

1 **Design Firm** Kircher, Washington DC
Client Hanley-Wood, LLC
Title Razor Scooter 3D Mailer
Art Directors Bruce E. Morgan, Dorothy Rudzik
Designer Bruce E. Morgan

2 **Design Firm** LIFT Packaging & Promotion Creatives, Atlanta GA
Client Cadbury Schweppes
Title Broadway Promotion
Art Director Jane Coker
Designer Rich Linden

3 **Design Firm** NDW Communications, Horsham PA
Client M-real
Title Sales Promotion for Zanders Ikono
Art Director Bill Healey
Designer Bill Healey
Photographers JD Marston, Kathleen Norris Cook

4 **Design Firm** NDW Communications, Horsham PA
Client Weyerhaeuser
Title Imagine Promotion for Cougar Opaque
Art Director Bill Healey
Designer Bill Healey
Photographers Dan Naylor, Carl VanderSchuit, Ann Cutting, White Packert, Jamie Stillings, Ralph Mercer

5 **Design Firm** Nicholson Design, Carlsbad CA
Client Marvin Rand, Mike Campos, Charles Slert
Title Charles Slert Associates Architects Calendar
Art Director N. Charles Slert
Designer Joe C. Nicholson
Illustrator Joe C. Nicholson

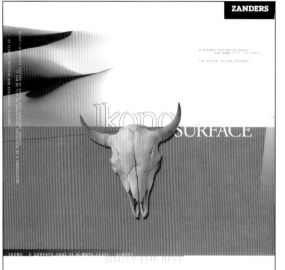

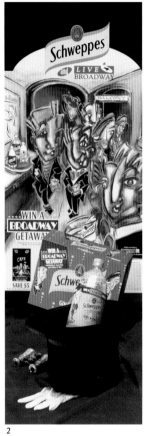

164

1

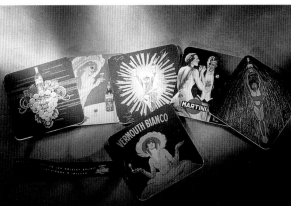

2

3

4

5

6

SALES PROMOTION

1 **Design Firm** Petertil Design Partners, Oak Park IL
 Client Hilco Receivables LLC
 Title Capabilities Brochure Series
 Art Director Rick Kaye
 Designers Annette McQuade, Kerry Petertil

2 **Design Firm** Pinkhaus, Miami FL
 Client Bacardi USA, Inc.
 Title Retro Coasters
 Art Director Claudia Kis
 Designer Mark Cantor

3 **Design Firm** Sullivan Creative, Watertown MA
 Client Mass Envelope Plus
 Title The Breakfast Buzz
 Art Director Dave Ferreira
 Designer Dave Ferreira
 Photographer Dave Ferreira

4 **Design Firm** Sunspots Creative, Inc., Hoboken NJ
 Client Corporate Jet Support
 Title Gulf Tags Trade Show Promo
 Art Director Rick Bonelli
 Designers Rick Bonelli, Deena Hartley
 Photographer Sandy Burstein

5 **Design Firm** Work Hard Play Hard, Inc., New York NY
 Title Bogdanoff Vodka
 Art Director Svelyn Bogdanoff
 Designer Cara Brendler

6 **Design Firm** Zinc, New York, NY
 Client Related Residential Development
 Title The Sierra Tin
 Designers Peter Maloney, Felicia Zekauskas

165

SELF PROMOTION

166

1

4

2

3

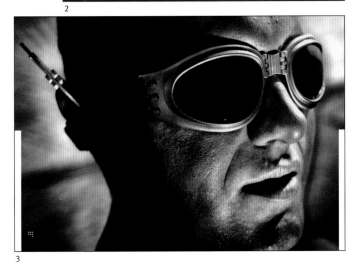

5

SELF PROMOTION

1 **Design Firm** Alcorn Publication Design, Graeagle CA
Title Promotional Brochure
Art Director David Alcorn
Designer David Alcorn
Photographer Lowell Martinsen

2 **Design Firm** Angeles Marketing Group, Glendale CA
Title Calendar
Art Director Paul Rottler
Designer Brigitte MacDonald
Illustrator Brigitte MacDonald
Photographer Brigitte MacDonald

3 **Design Firm** Archetype Group Inc., Green Bay WI
Title Evolutionaries Brochure
Art Director James Rivett
Designer Kimberly Baldridge
Photographer Steve Eliasen

4 **Design Firm** BD&E, Pittsburgh PA
Title Company Calendar
Art Director Jeff Piatt
Designer Susan Limoncelli
Photographer Harry Giglio

5 **Design Firm** Belyea, Seattle WA
Title 4 & 20 Blackbirds Calendar
Art Director Patricia Belyea
Designer Naomi Murphy
Calligrapher Nancy Stentz
Photographer Rosanne Olson

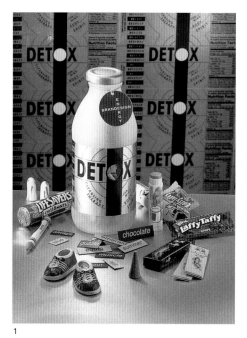

1

3

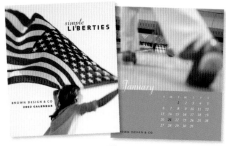

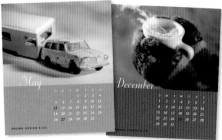

2

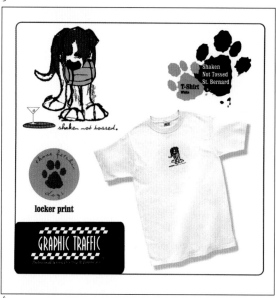

4

5

1 **Design Firm** Brandesign
Incorporated, Monroe NJ
Title Detox Self Promotion
Art Director Barbara Harrington
Designers Jonathan Licht,
Ed Mullowney

2 **Design Firm** Brown Design &
Company, Portland ME
Title Simple Liberties Calendar
Art Director Mary Brown
Designer Mary Brown
Photographer Hugh Brantner

3 **Design Firm** Catalpha Advertising &
Design, Towson MD
Client Catalpha
Title Self Mailer/Promotion
Art Director Michael Garlitz
Designer Michael Garlitz
Photographer Bill Schilling

4 **Design Firm** ChickenScratches
Design, Sandy UT
Title Those Fetchin' Dogs
Art Director Heidi Jo Gilbert
Designer Heidi Jo Gilbert
Illustrator Heidi Jo Gilbert

5 **Design Firm** Clive Jacobson Design,
New York NY
Title Look at Me
Art Director Clive Jacobson
Designer Clive Jacobson
Illustrator Clive Jacobson
Photographer Clive Jacobson

1

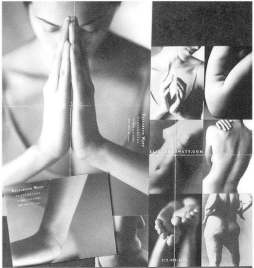

2

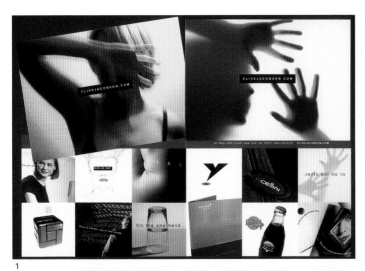

3

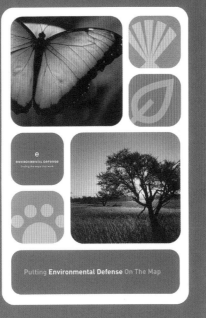

focus: development

December

4

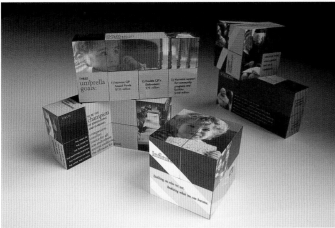

Putting **Environmental Defense** On The Map

5

SELF PROMOTION

1 **Design Firm** Clive Jacobson Design, New York NY
Title Or On the Other
Art Director Clive Jacobson
Designer Clive Jacobson
Illustrator Clive Jacobson
Photographer Clive Jacobson

2 **Design Firm** Clive Jacobson Design, New York NY
Client Elizabeth Watt
Title Nudes
Art Director Clive Jacobson
Designer Clive Jacobson
Photographer Elizabeth Watt

3 **Design Firm** Combined Jewish Philanthropies, Boston MA
Title Magic Cube Promo
Art Directors Peter McDonald, Terry Holzman
Designer Peter McDonald
Photographers Joshua Dalsimer, Jim Thomas

4 **Design Firm** Computer Associates International, Inc., Islandia NY
Title 2002 Computer Associates Calendar
Art Director Loren Moss Meyer
Designer Loren Moss Meyer
Photographer Pete Mcarthur

5 **Design Firm** Concept Foundry, Bethesda MD
Client Environmental Defense
Title Putting Environmental Defense on the Map
Art Director Page Hayes
Designer Page Hayes

1

4

2

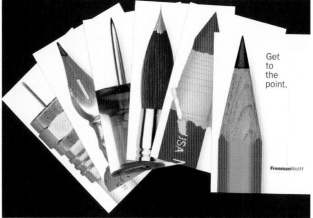

5

3

SELF PROMOTION

1 **Design Firm** Courtney & Company Design, Liverpool NY
 Client Perceptions/King & King Architects
 Title Image Is Everything
 Designer Cynthia Courtney
 Illustrator Cynthia Courtney

2 **Design Firm** Crawford/Mikus Design, Inc., Atlanta GA
 Title Christmas Card
 Art Director Elizabeth Crawford
 Designer Studio
 Illustrator Elizabeth Crawford

3 **Design Firm** Epstein Design Partners, Inc., Cleveland OH
 Client City of Shaker Heights
 Title Promotional Packet
 Designer Marla Gutzwiller
 Photographer Don Snyder

4 **Design Firm** Faust Associates, Chicago IL
 Client Faust Associates, Chicago
 Title In Good Company-Self Promotion Booklet
 Art Director Bob Faust
 Designer Andrew Waiss

5 **Design Firm** Freeman Wolff Design & New Media, Tenafly NJ
 Title Get to the Point
 Art Director Irving Freeman
 Designer Punz Wolff
 Photographer Punz Wolff

1

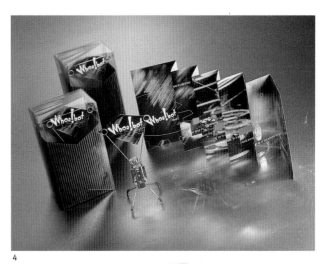

4

2

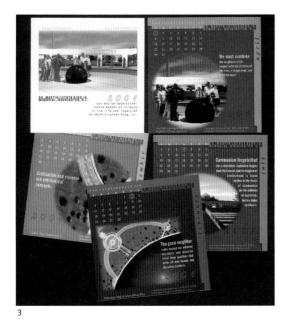

3

5

SELF PROMOTION

1 **Design Firm** Gauger & Santy, San Francisco CA
 Title Brochure
 Designer David Gauger

2 **Design Firm** Gunter Advertising, Madison WI
 Title Join the Gang Web Site
 Art Director Randy Gunter
 Designers Sarah Grimm, Collin Schneider
 Illustrator Sarah Grimm

3 **Design Firm** i design: information, Downingtown PA
 Title Twelve Months of Tribute: Dr. Martin Luther King, Jr. Memorial
 Art Director Joel Avery
 Designer Joel Avery
 Illustrator Joel Avery
 Photographer Joel Avery

4 **Design Firm** Interbrand Hulefeld, Cincinnati OH
 Title Whoa!bot
 Art Director Jodi Sena
 Designer Jodi Sena
 Photographer Roy Klein

5 **Design Firm** KruegerWright, Minneapolis MN
 Title Versus
 Art Director Patrick Kendall
 Designers Karen Wright, Joe Morris

1

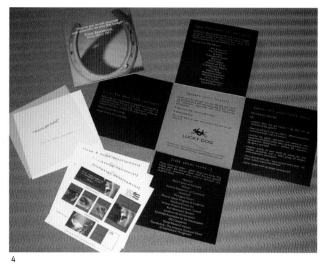

imagine...

july

sunday monday tuesday wednesday thursday friday saturday

5

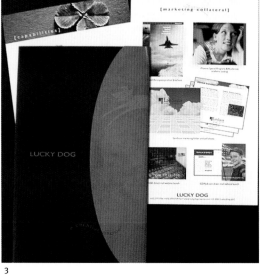

2

3

4

SELF PROMOTION

1 **Design Firm** Laura Coe Design Associates, San Diego CA
 Title Note and Post Card Series
 Art Director Laura Coe Wright
 Designer Ryoichi Yotsumoto
 Illustrator Ryoichi Yotsumoto

2 **Design Firm** LTD Creative, Frederick MD
 Title Self Promotion
 Art Director Timothy Finnen
 Designer Louanne Welgoss
 Illustrator Timothy Finnen

3 **Design Firm** Lucky Dog, Phoenix AZ
 Title Marketing Folder and Inserts
 Art Director Mark Howard
 Designer Tom Howard

4 **Design Firm** Lucky Dog, Phoenix AZ
 Title Direct Mail Teaser
 Art Director Mark Howard
 Designer Tom Howard

5 **Design Firm** March of Dimes, Mamaroneck NY
 Title 2002 Calendar
 Art Directors Barbara Jones, Sharon Mahoney
 Creative Director Kathy D'Aloise
 Designer William Masto
 Photographer Jennifer Coate

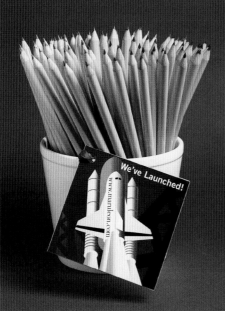

1

2

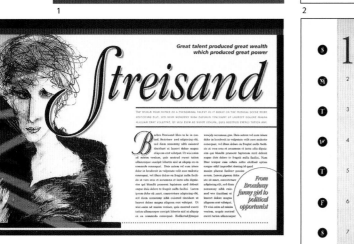

3

4

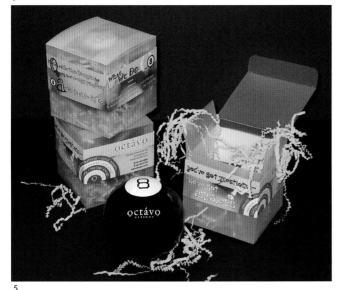

5

SELF PROMOTION

1 **Design Firm** Maru León Design, New York NY
Title Web Site Self Promotion
Art Director Maru León
Designer Jorge Stark

2 **Design Firm** Methodologie Inc., Seattle, WA
Title Show & Tell
Art Director Anne Traver
Designers Gabe Goldman, Dale Hart

3 **Design Firm** Mickey Moore and Associates, Charlottesville VA
Title Streisand - Mock Editorial Spread
Art Director Mickey Moore
Designer Mickey Moore
Illustrator Mickey Moore

4 **Design Firm** Minx Design, Akron OH
Title 2002 Calendar
Designer Cecilia M. Sveda

5 **Design Firm** Octavo Designs, Frederick MD
Title 8 Ball Promotion
Art Director Sue Hough
Designer Eryn Willard
Illustrator Eryn Willard

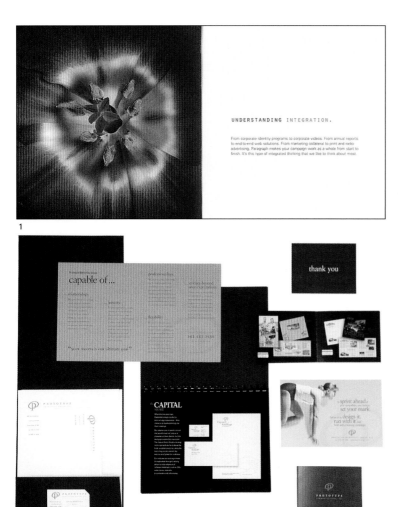

1

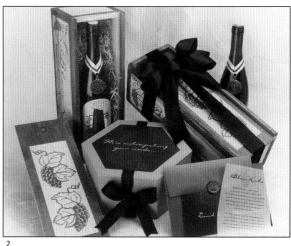

2

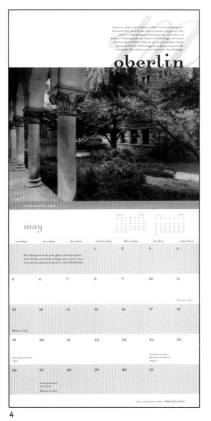

3

4

5

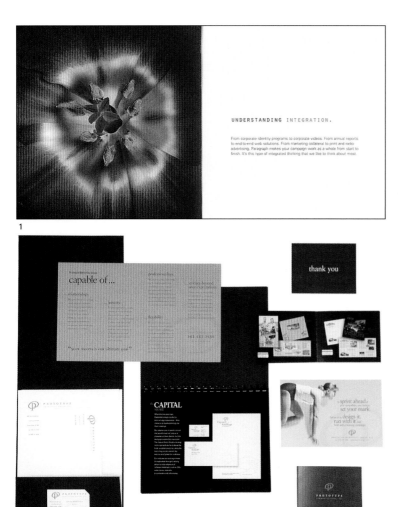

SELF PROMOTION

1 **Design Firm** Paragraph, Philadelphia PA
 Title Self Promotion
 Art Director Bob Aretz
 Designer Bob Aretz
 Photographer Nick D'Amico

2 **Design Firm** Progressive Impressions International, Bloomington IL
 Client Pii Self Promotion to American Express
 Title Blue Love Campaign
 Creative Director Brian Phipps
 Art Director Jennifer Givler
 Designer Jennifer Givler
 Writer Karl Stull

3 **Design Firm** Prototype Marketing Group LLC, South Plainfield NJ
 Title Self Promotion
 Art Director Joe Domalewski
 Designer Joe Domalewski

4 **Design Firm** SCK Design Inc., Cleveland OH
 Client Oberlin College
 Title 2002 College Calendar
 Art Director Leo Kosir
 Designer Leo Kosir
 Photographer Al Fuchs

5 **Design Firm** Scott Design Communications, Inc., Philadelphia PA
 Title Creating Inspired Communications
 Art Director Helene Krasney
 Designer Jeanine Testa

1

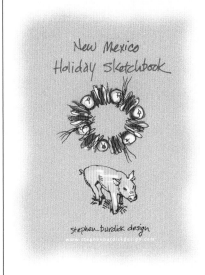

2

3

4

5

The Edelman Group
420 Lexington Ave, Suite 1706
New York, NY 10170

Happy New Year from The Edelman Group!

6

SELF PROMOTION

1 **Design Firm** Sewickley Graphics & Design, Inc., Sewickley PA
Title Self Promotion
Art Director Michael Seidl
Designer Michael Seidl
Illustrator Michael Seidl
Photographer Ed Rombout Photography

2 **Design Firm** Stephen Burdick Design, Boston MA
Title New Mexico Holiday Sketchbook
Art Director Stephen Burdick
Designer Stephen Burdick
Illustrator Stephen Burdick

3 **Design Firm** Sun Graphics, Westerly RI
Title Butterfly Brochure
Art Director Andrew Burris
Designer Andrew Burris
Illustrator Andrew Burris
Photographer Andrew Burris

4 **Design Firm** Sunspots Creative, Inc., Hoboken NJ
Title Identity Crisis
Art Director Rick Bonelli
Designers Rick Bonelli, Deena Hartley
Photographer Sandy Burstein

5 **Design Firm** Tamada Brown & Associates, Chicago IL
Title What Do You See?
Art Director Phyllis Tamada-Brown
Designers Phyllis Tamada-Brown, Laura Gannarelli, Andy Wong
Photographer Werner Staube

6 **Design Firm** The Edelman Group, New York NY
Title Holiday Mailer 2001
Art Directors Terri Edelman, Michelle Iseley
Designer Jeremy Mickel

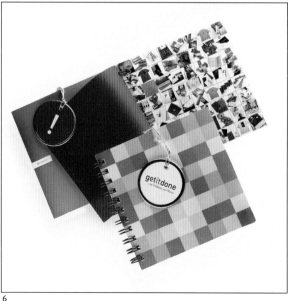

SELF PROMOTION

1 **Design Firm** The Jones Payne Group,
Boston MA
Title Postcard Mailer
Designers Peter J. Raneri,
Cheryl Gurvich

2 **Design Firm** The Shamrock
Companies Inc., Westlake OH
Title Shamrock Postcards
Art Directors Dave Larson,
John Bennett
Designer Lori Leiter

3 **Design Firm** Westat Graphic Arts
Department, Rockville MD
Client Westat
Title Field Staff Calendar 2002
Art Director Shayna Heller
Designer Angelica Nuñez

4 **Design Firm** whiteSTARdesign,
Bethlehem PA
Title Annual Report Mailer &
Follow Up Postcards
Art Director Peter Stolvoort
Designers Peter Stolvoort,
Wojciech Goleniewski

5 **Design Firm** whiteSTARdesign,
Bethlehem PA
Title Art Within Art Mailer
Art Director Peter Stolvoort
Designers Peter Stolvoort,
Wojciech Goleniewski

6 **Design Firm** Williams and House,
Avon CT
Title Get it Done Brochure
Art Director Pam Williams
Designer Fred Schaub
Copywriter Pam Williams
Photographer Scott Van Sicklin

firms represented

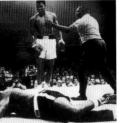

firms represented

firms represented

firms represented

firms represented